To Anthony and Jane,
Love from,
Tim

KINGSTON
UPON THAMES
THEN & NOW

IN COLOUR

TIM EVERSON

The
History
Press

First published in 2012

The History Press
The Mill, Brimscombe Port
Stroud, Gloucestershire, GL5 2QG
www.thehistorypress.co.uk

British Library Cataloguing in Publication Data.
A catalogue record for this book is available from the British Library.

ISBN 978 0 7524 7158 7

Typesetting and origination by The History Press
Printed in India.
Manufacturing managed by Jellyfish Print Solutions Ltd

CONTENTS

Acknowledgements 4

About the Author 4

Introduction 5

Kingston upon Thames Then & Now 6

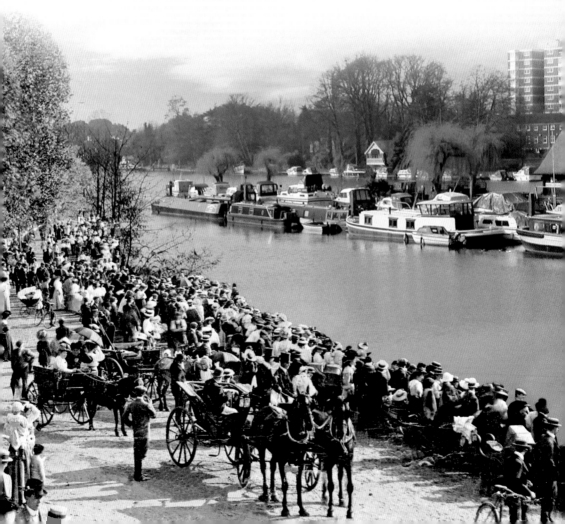

ACKNOWLEDGEMENTS

I would like to thank everyone on the staff of Kingston Museum & Heritage Service who provided all the old photographs in this book, and especially to Margaret Kelly and Sylvia Oliver who helped with picture choice. For sources I must thank my wife, Shaan Butters, for her *Book of Kingston* and for the use of various unpublished notes, especially on churches. I must also thank June Sampson for her *All Change* and many other books and articles written in the *Surrey Comet*, and I must thank Richard Holmes for his book, *Pubs, Inns and Taverns of Kingston*, which has been most useful. Finally, I must thank my wife for reading this through and saving me from some embarrassing errors! All the modern pictures are my own and were taken in the winter of 2011-12. I am grateful for the reasonable weather I had on most days!

ABOUT THE AUTHOR

A passionate local history author, Tim Everson has been researching and writing about Kingston upon Thames and the surrounding area since the early nineties. He has had numerous works published, was editor of *Surrey History* from 1994 to 2004 and Local History Officer for the Royal Borough of Kingston upon Thames from 1990 to 2001. He is currently a full-time writer and lives in Surrey.

INTRODUCTION

Kingston upon Thames was recently voted the best place in which to live, having all the advantages of both town and country. There are shops aplenty, good schools, restaurants, clubs, a cinema and an excellent theatre. Kingston is also close to Richmond Park, Hampton Court, Bushy Park, Wimbledon Common and the Surrey countryside. It is, in short, a lovely place to live in, and the author has spent eighteen happy years here. But was this always the case?

Kingston means 'King's Estate', and in the tenth century some Anglo-Saxon kings of England were crowned here. From the twelfth-century Kingston became a town when the first bridge was built across the Thames and a marketplace developed. Kingston has been principally a shopping town ever since, drawing people in from all over Surrey and other parts of London.

This book looks at the last 100 years or so of Kingston's history and shows that there was (and is) more to Kingston than shops. The river was a vital source of trade but, from the late nineteenth century, it also became a place of entertainment where regattas were held. It was also useful to the boat-building industry and later to Sopwith's, whose float-planes could use the Thames as a runway. Industries based on the old mills on the Hogsmill River also thrived and people flocked to Kingston in search of work. This influx had begun with the advent of the railways in the mid-nineteenth century, which led to the development of the two great suburbs (towns in their own right, really) of Surbiton and New Malden. In the 1920s and 1930s the last of the green fields of Kingston's farm land were covered in houses. This finished off the old cattle market formerly held in Kingston, but the market adapted and survives to this day. Kingston's flagship store, Bentalls, started life in 1867 and became the magnet which drew other shops to the town. In recent years it adapted and changed itself into a shopping centre, giving the public even more choice and making Kingston one of the most sought after towns in which to have a shopping outlet. As a result, Kingston has survived the recessions of the 1930s, the 1970s and the current crisis much better than other towns. In 1980, Kingston finally said farewell to its industry. With the closure of VP Wines and British Aerospace (the descendent of Sopwith and of Hawker), Kingston found itself without a major industrial employer. On the other hand, the rise of Kingston University has brought much investment and employment to the town, and the students support many of the retail outlets.

Education has always been of supreme importance to the people of Kingston. A museum was built in 1904 and Kingston remains one of the few London boroughs to possess such a gem. The borough successfully fought off the introduction of comprehensive schools, which is why Kingston's pupils are some of the best educated in Britain today. The recent arrival of the Rose Theatre has brought some much-needed additional culture to the town.

So the mainstay of shopping has supported the town whilst industry has come and gone, and opportunities for education and leisure have increased. The pictures in this book will give you some idea of what Kingston has been like and what it is like now. In truth, it has probably always been one of the best places to live, then and now.

KINGSTON'S CORONATION STONE

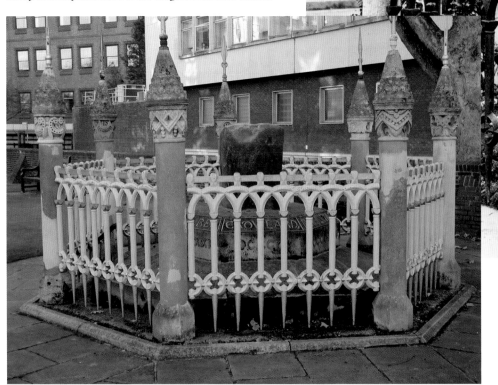

THIS STONE IS possibly the coronation stone on which seven Anglo-Saxon kings of England were crowned in the tenth century. Its importance was recognised in the nineteenth century, and in 1850 it was set up at the southern end of the Market Place surrounded by these railings. This photograph shows the stone and railings decorated with flowers to celebrate both the coronation of Edward VII in 1902, and also the millenary of the coronation of Edward the Elder in 902.

THE STONE WAS moved as a traffic hazard in 1935 and set up on this platform over the Hogsmill Stream outside

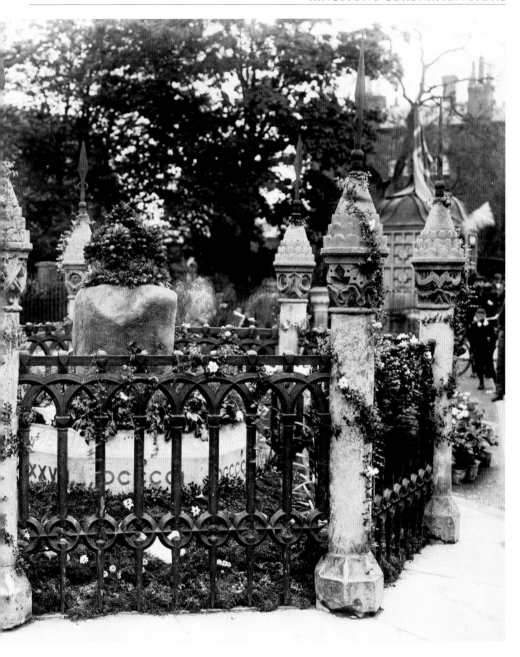

Kingston's Guildhall. It is not very prominent here and tourists often have difficulty finding it. In 2012 or 2013 it is hoped that the stone, along with its Victorian plinth and railings, will be moved to a more fitting location on the north side of All Saints' church. This would probably be closer to where the coronations actually took place. Aubrey, writing in the seventeenth century, suggests that some kings were crowned in the Market Place, whereas others were crowned in the church, or perhaps in the adjoining St Mary's Chapel, which fell down in 1730.

THE MARKET PLACE

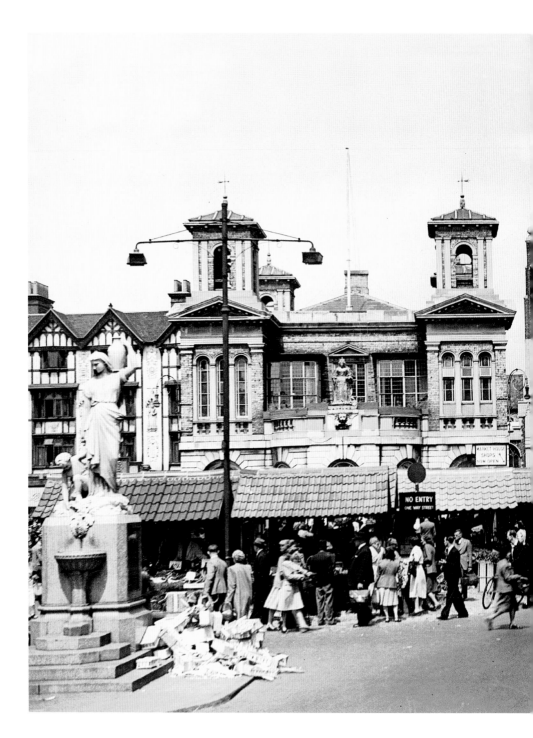

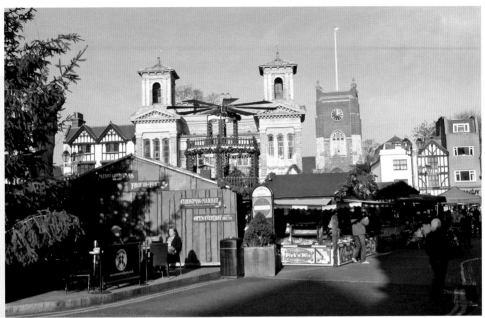

KINGSTON MARKET PLACE ,1948. The Market Place has remained pretty much the same since 1840, when the Market House was built as a new Town Hall. However, there have been many minor changes. Here are the tiled roofs that were newly installed just after the war but which were taken down in the 1970s.

KINGSTON MARKET PLACE dates to the twelfth century. It may have evolved gradually, but there is also the possibility that it was centrally planned by the king, Henry II. The Market Place at Christmas shows the small German market which has been a feature of Christmas in Kingston since the mid 1990s. On the left, a tree partially obscures the Shrubsole fountain, built in 1882 to commemorate a much-loved mayor who died in 1880 (his date of death is actually incorrect on the monument). In the centre is a 'Pyramide', a revolving decoration from Germany, here marking the location of the mulled wine stall. Plans are afoot to redesign the ordinary market stalls and give the whole area a new lease of life.

EAST SIDE OF
THE MARKET HOUSE

TANK IN KINGSTON Market Place, 1918. One money-raising effort of the First World War was Kingston Tank Day in March. This involved using a tank as an office from which to sell war bonds, the tank in this case being 'Iron Ration'. It was also a great opportunity to climb on to

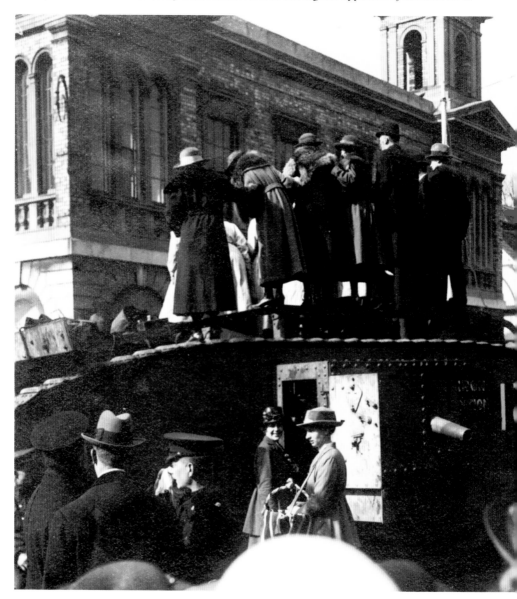

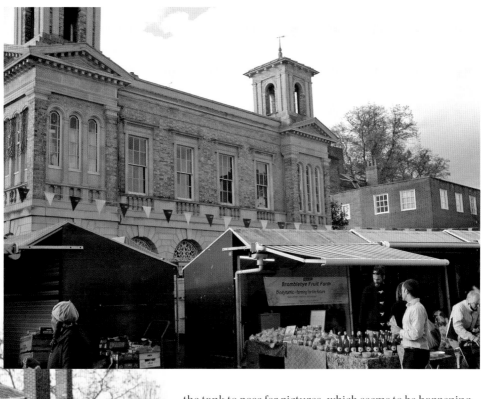

the tank to pose for pictures, which seems to be happening here. Harry Hawker added to the entertainment by flying a Sopwith Dolphin over the town and dropping leaflets about the bonds. Tank Day raised £187,767.

THIS VIEW SHOWS the more normal type of stall in Kingston Market, which remains mainly a food market. This side of the market was known in medieval times as Cook's Row and was mostly occupied by butchers. To the right of the picture, the north-east corner was known as the oat market, and a separate building stood here from around 1690 to around 1790. Market day was originally only on a Saturday, but Charles II added Wednesday as well. His father, Charles I, stipulated that no other market could be held within seven miles of Kingston, a right vigorously defended until the 1970s, when taking Brentford to court was successful but cost too much ratepayers' money. Today the Market Place often plays host to special food markets, such as a French market or an Italian market. A more regular farmers' market is planned.

11

HARROW PASSAGE

HARROW PASSAGE, c.1910. This passage joins Kingston Market Place to the Apple Market and is named after The Old Harrow public house, which is on the left of the picture. This view is often shown on old postcards as 'A Bit of Old Kingston', and indeed the buildings date from around 1500. In the foreground is an iron pillar manufactured by Harris and Son and featuring the three salmon of Kingston's coat of arms. The Old Harrow closed in 1912.

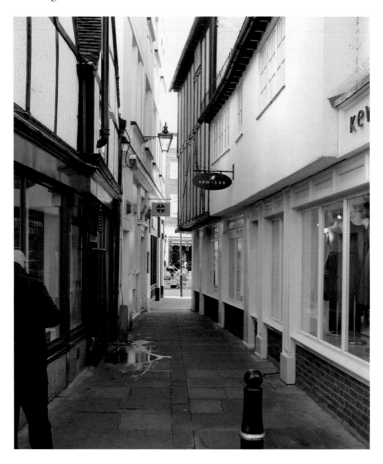

TODAY THE VICTORIAN iron pillar has been moved to join its fellows at the southern end of the Apple Market and a modern pillar now stands in the way, though its purpose is beyond me – vehicular access here was never an option! The Harrow on the left is now Stiles Bakery, also a café. The building on the right was Follets the butcher for many years and proudly proclaimed that they, or at least the building, dated to 1422. I have not discovered the origin of this claim, but the building is certainly no older than the 1500s. Follets was followed by Drugmart, a chemist, Wallspan Bedding and then Laura Ashley. Today it is Kew, a clothing shop.

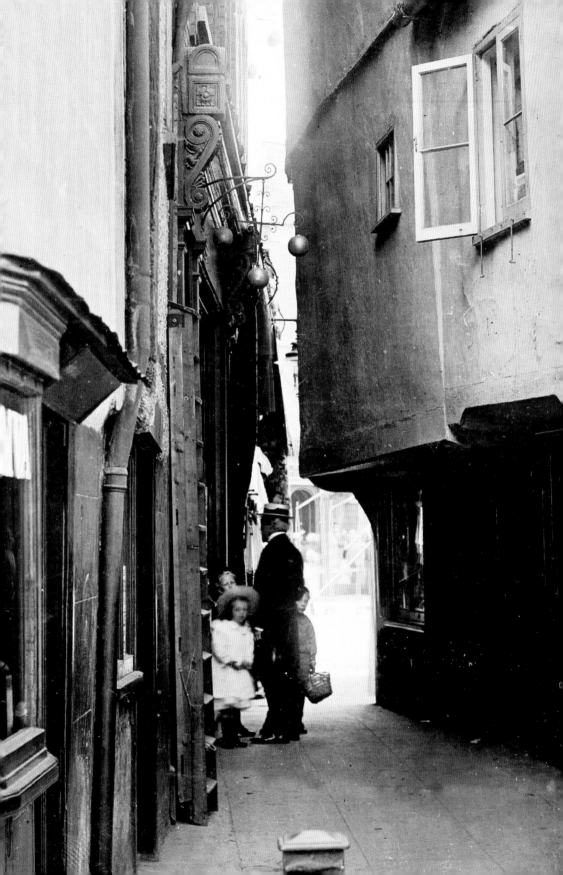

THE NORTH-WEST CORNER OF THE MARKET PLACE

THE SUN HOTEL, 1927. This was one of Kingston's oldest coaching inns, and it had an excellent reputation by the eighteenth century. It had previously been known as The Saracen's Head and was built before 1400. The Victorian railways killed off much of its trade. In the old photograph it is derelict, awaiting an auction of its entire contents. In 1931 it was demolished and a new Woolworths store was built in its place.

THE WEST SIDE of the Market Place used to be almost entirely occupied by inns. The Sun, the Griffin, the Castle, the Crown, the Crane, the George and the Swan have all gone. Only the

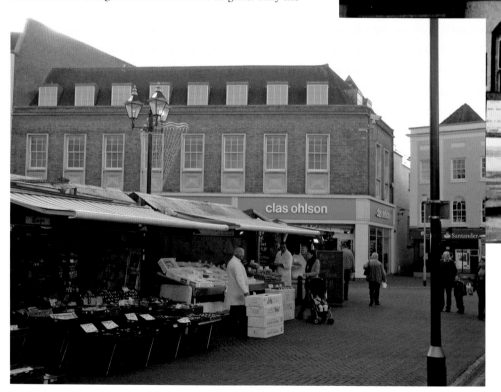

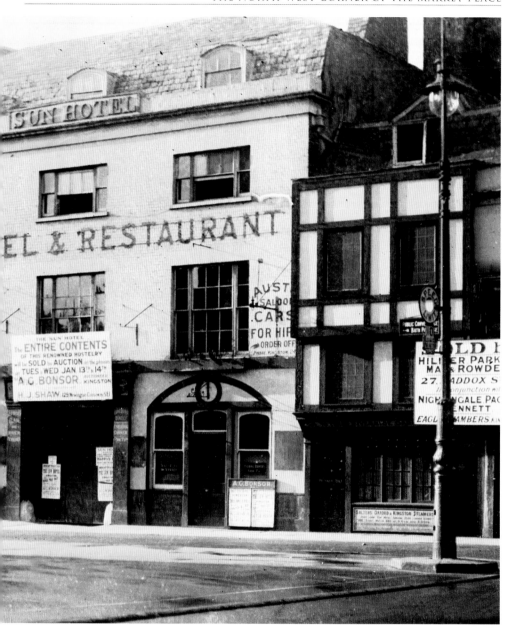

Druid's Head survives. The others had flourished with the coaching trade, which died with the advent of the railways. Woolworths, of course, famously closed in 2009 but the site was rapidly purchased by Clas Ohlson, a Swedish hardware store. They only opened their first shop in the UK in 2008 (in Croydon) and already have twelve British stores as they rapidly expand, frequently by buying defunct Woolworths stores. More market stalls can be seen on this north side of the Market Place in front of the Market House, whilst the East Surrey Memorial gates to All Saints' church are on the right, out of shot.

No. 35 HIGH STREET

THOMAS ABBOTT'S CHINA shop, 1902. Thomas Abbott's shop was here from 1850 through to 1927. He was an internationally famous china restorer as well as dealer. He was chosen to

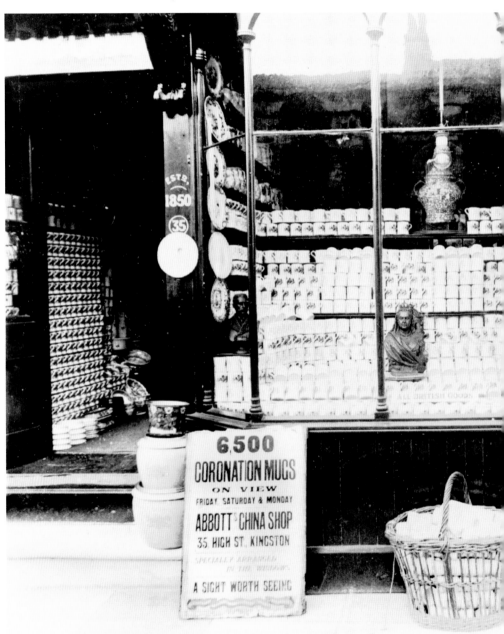

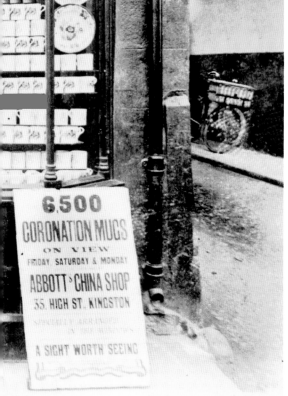

repair some of Catherine the Great's dinner service. Here he has filled his windows with a display of 6,500 coronation mugs for the coronation of Edward VII.

THE HIGH STREET, which is the street running south from the Market Place alongside the river until it becomes the Portsmouth Road, is not the main shopping street. This confuses many visitors. High Street used to be a haven of old buildings. Looking eastwards, the road on the right of this picture is East Lane, and Nando's Portuguese Restaurant and the Pizza Express next door do contain some sixteenth-century timbers, but the old malt house is gone (illegally demolished in 1965) and, as can be seen, so is Abbott's old china shop. High Street now has several rather nondescript offices like this one in between the restaurants.

CLARENCE STREET

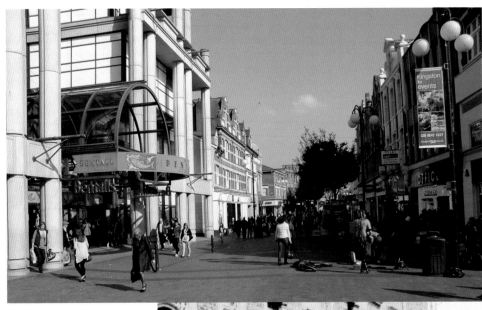

CLARENCE STREET, 1910.
Named after the Duchess
of Clarence in 1828
when she opened the new
Kingston Bridge, this main
thoroughfare was originally
just called London Road or
sometimes Norbiton Street.
Even in 1910, Kingston was
busy. One of the new trams
can be seen in the vintage
photograph, as well as three
other motor vehicles. Notice
also Bentalls store on the left
advertising its fifty separate
departments. This postcard
was sent from Walton
on Thames to a friend in
Philadelphia. The writer
had just visited Kingston for
the regatta.

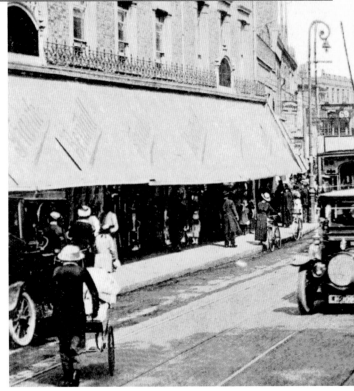

CLARENCE STREET IS the street most people mean when they say 'High Street'. In the early 1990s Bentalls department store relocated onto the northern half of their site, whilst the southern half was redeveloped as the Bentall Centre, a shopping mall owned jointly by Bentalls and Norwich union. Although Bentalls have now given up their share, and the store itself became part of the Fenwick group some ten years ago, Bentalls remains the heart of shopping in Kingston, and has been since 1867. One of the many buskers that are usually here is in full flow on the right of the picture.

EAST END OF
CLARENCE STREET

L. GOODMAN, TAILOR, No. 79 Clarence Street. This photograph is conveniently dated 5 April 1928, but even without that it is an easy picture to date since Goodman's was here only from late 1927 until sometime in 1928. His 50 shilling suits failed to take off but his business was

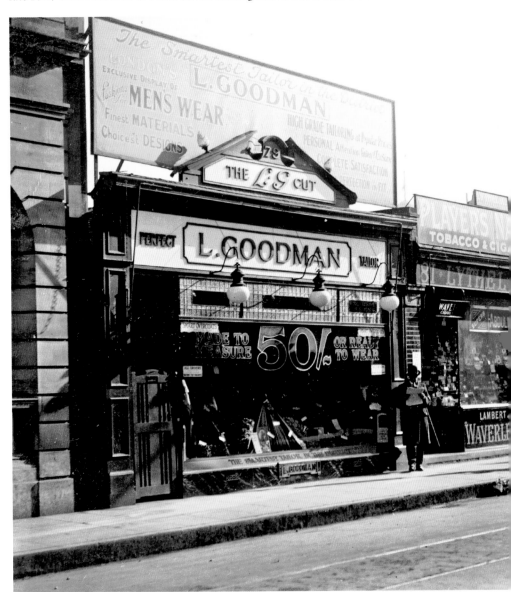

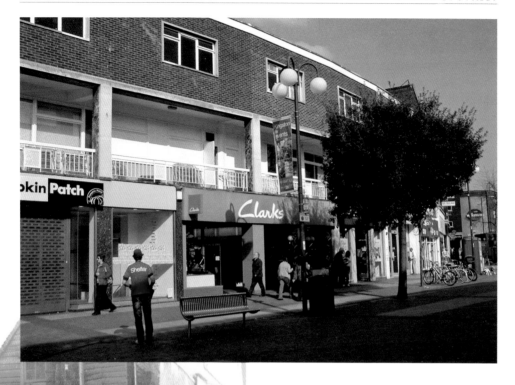

bought by Nathan Berg, who was there for a long time until Peter Lord took over. Only in recent years has it ceased to be a tailor's. It is now a Clarks shoe shop.

THE LOW-RISE shops have been replaced by these three-storey blocks, which seem obligatory today and are difficult to cheer up. Clarence Street was pedestrianised in 1989 to make it a safer street for shoppers. It is still a busy thoroughfare with cyclists (banned in theory), skateboarders, buskers, people holding large advertising signs and collectors for various charities. There is also a wealth of street furniture – benches, bins and bollards – but also some beautifully designed roundels in the pavement symbolising the different parts of the borough. There are still some interesting architectural features. Always remember to look above the bland shop fronts, as you will sometimes be pleasantly surprised (though not in this picture!).

21

THE RED LION, KINGSTON

RED LION, WOOD Street, 1930. The Red Lion was built shortly before 1848 as a beer and lodging house to serve the growing population of the Canbury area of Kingston. It became a licensed premises after 1870 but probably never sold spirits. The building shown here is a rebuild of 1905. It was purchased by Bentalls in 1929 along with the adjoining properties.

THE RED LION was demolished in 1930, along with all the other properties on this side of Wood Street, including the old vicarage. Bentalls then rebuilt their large department store, giving it a façade to match that of nearby Hampton Court Palace. When this part of the store was redeveloped into the Bentall Centre, this Aston Webb Façade, named after the architects' firm, was preserved, and its preservation was commemorated by a plaque unveiled by the Queen in 1992 when she visited Kingston to celebrate the 40th anniversary of her accession. This was only the Queen's second visit to the royal borough. She had previously visited in 1961 to celebrate the 400th anniversary of Kingston Grammar School.

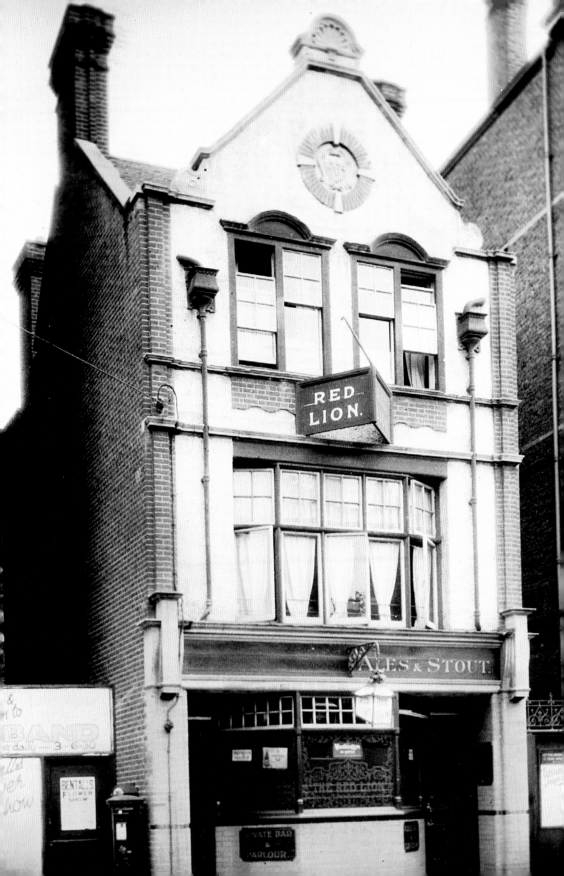

BENTALLS

THIS 1935 PHOTOGRAPH shows three different sections of Bentalls on Clarence Street. On the extreme left is part of the new façade, in the middle a 1920s section and, on the right, part of the old Victorian premises. Traffic was still two-way in Clarence Street at this time. There is

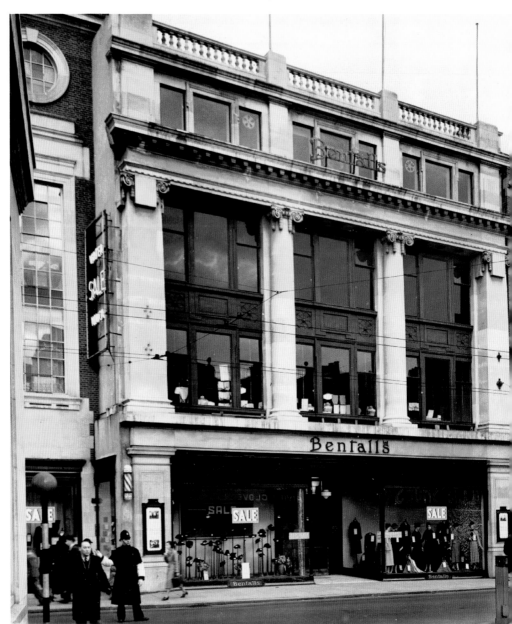

a policeman to the left keeping an eye on it, whereas to the right is an old-fashioned sandwich-board man.

THE 1935 FAÇADE at left is still there but the rest of the frontage has been replaced by the new Bentall Centre, opened in 1992 and designed as a cathedral for shopping. The traffic became one-way in 1962 but Clarence Street remained a dangerous place for pedestrians, despite a crossing outside Marks & Spencer. In 1989 the street was pedestrianised and is still a very busy place. During the recession, the Bentall Centre has had its fair share of failed shops, but there is always a new business ready to step in, and units are never empty for very long. Kingston's Chamber of Commerce, known as Kingston First, have benefited the town greatly by helping to keep it clean and attracting visitors.

CINEMAS OLD AND NEW

THE KINGSTON KINEMA in Clarence Street, 1968. Built at the corner of Richmond Road, this cinema was opened in 1910 as Kingston Picture Theatre. It was enlarged in 1930 when it was renamed Kingston Kinema. In 1970 it was again revamped and renamed Studio 7. This tended to specialise in films of a dubious nature, frequently involving 'Swedish' in the title.

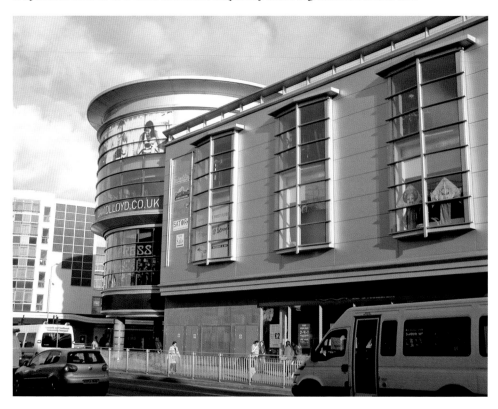

WHEN CINEMAS WERE at their most popular, from the 1930s to the 1950s, Kingston could boast five: the Elite (closed 1955), the Odeon (closed 1967), the Regal (closed 1975), the Granada (closed 1987) and Studio 7. Studio 7 closed in 1983. It was replaced by Pine World furniture store between 1983 and 1999 whilst the site was earmarked for redevelopment, along with the neighbouring bus garage. A new cinema was always planned and in 2000 the Rotunda complex opened on the site featuring fourteen screens, along with a ten-pin bowling alley, a David Lloyd club and various restaurants. To the right, the old Granada site became a nightclub, originally Options, now Oceana. The Rotunda (an Odeon Cinema) is now the only cinema in the whole borough.

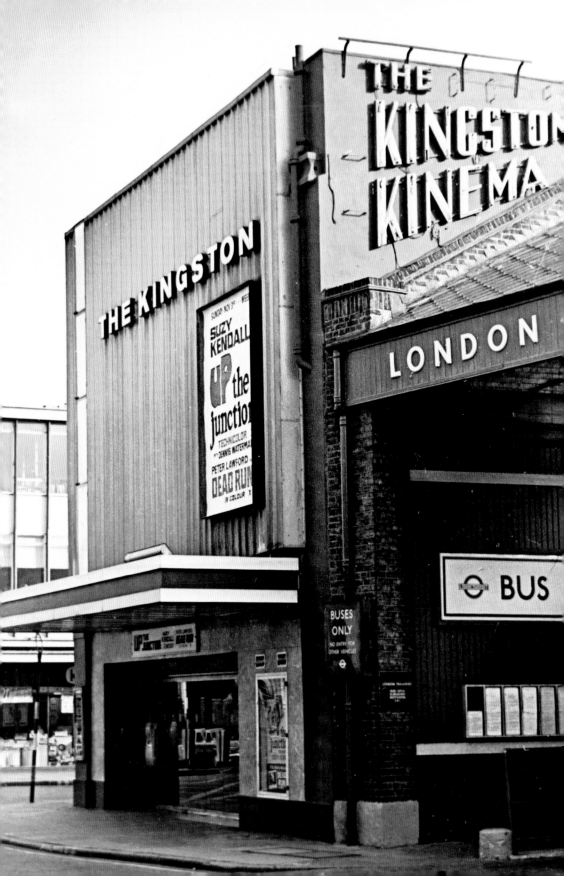

THE THAMES

THE FROZEN THAMES in 1940: a peaceful picture in a time of war. This was 23 January 1940 and shows one of the last occasions on which the Thames froze at Kingston. It happened to an extent in the winter of 1946-7, but the new power station built in 1948 has kept the Thames too warm for freezing ever since. The old power station can be seen in the background beyond the gazebos of British Home Stores.

THE POWER STATION closed in 1980 and the chimneys were

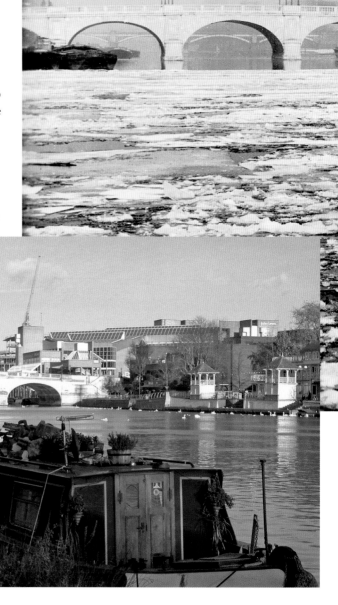

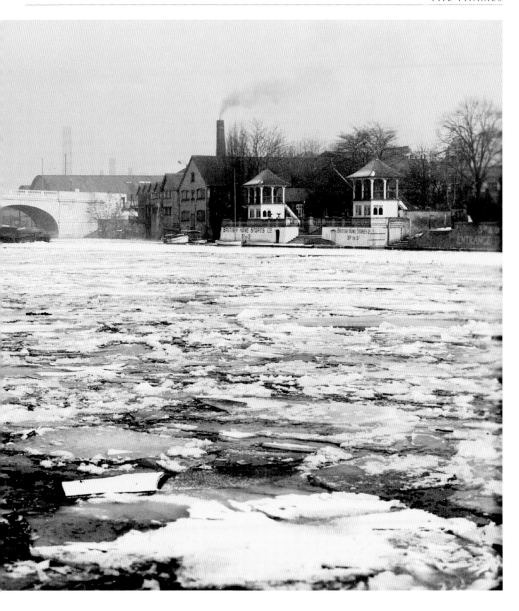

pulled down in 1994. Today the background is dominated by the John Lewis store, built in 1990. The gazebos, originally built for Nuthalls restaurant in 1902, are still across the river, though no longer accessible, and are part of the Charter Quay development of restaurants, bars and apartments. Where the River Hogsmill joins the Thames has been set aside for wildlife, and this attracts large numbers of swans, ducks and Canada Geese. In the foreground is an old barge, several of which are moored on this side of the Thames. There are always more people with boats than there are available moorings. The Charter Quay development removed several moorings, much to the annoyance of local river folk.

NORTH OF
CLARENCE STREET

KINGSTON LUXURY COACHES, February 1959. This coach station was at the junction of
Thames Street and Old Bridge Street. It was built in 1932, although the firm was older, having

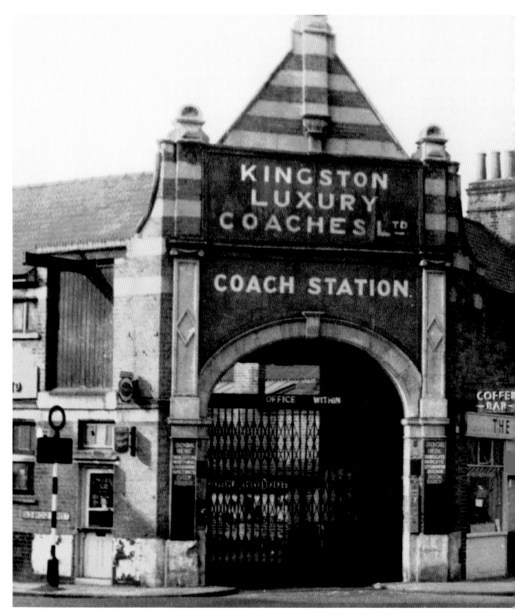

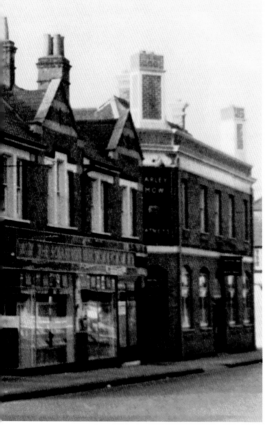

premises at Brook Street back in the 1920s. The coaches stayed until the early 1970s, when the station was demolished to form a car park.

THE CAR PARK was always a temporary measure whilst the site awaited redevelopment. There was originally going to be a complete ring road around Kingston, which would have demolished the museum and library (!) and which would have placed a dual carriageway between the Market Place and the river. After lengthy negotiations concerning the route of a proposed through-road instead, John Lewis bought the site and opened their store in 1990. They had been trying to get a store in the town since 1974. The site of the old coach station is now the underpass which goes through the middle of John Lewis. This makes for some interesting floor arrangements within the store. This underpass is called Horse Fair after the old part of Kingston market which used to be here.

CLATTERN
BRIDGE

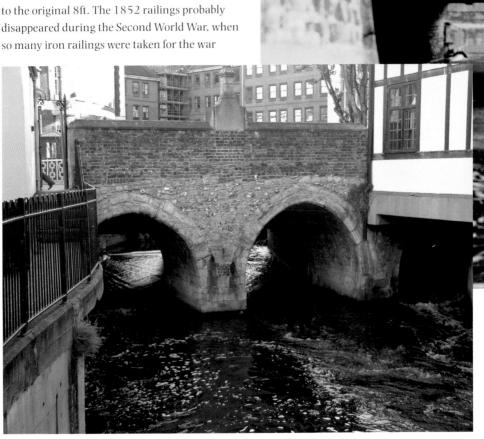

CLATTERN BRIDGE, 1905. One of the oldest
structures in the borough, Clattern Bridge was
built in about 1200 over the Hogsmill River in
order to connect the south of Kingston with the
Market Place. This photograph shows the original
stone arches but the upper works are Georgian
and Victorian bricks. The stone parapets were
replaced some time before 1673. The bridge was
widened in 1758 and again in 1852, when new
railings were also put in.

CLATTERN BRIDGE IS now 36ft wide, compared
to the original 8ft. The 1852 railings probably
disappeared during the Second World War, when
so many iron railings were taken for the war

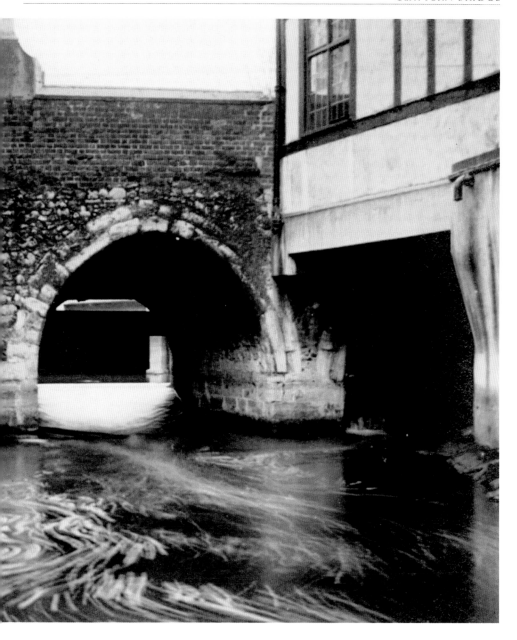

effort. The new footway to the left leads down to the Charter Quay area and the Thames. The modern photograph shows more clearly Clattern Bridge's third arch, which is often overlooked, beneath the building opposite. This building is nineteenth-century brick and had the timbers added in Edwardian times to make it look medieval, a frequent occurrence in Kingston. The name Clattern almost certainly derives from 'clattering', referring to the noise of horses' hooves and cart wheels over the original cobbles. Clattern Bridge marked the southern boundary of Kingston in medieval times.

PICTON HOUSE

PICTON HOUSE, 1955. An early success for the Kingston Society and Kingston upon Thames Archaeological Society was the saving of this house when it was threatened with demolition in 1973. It dates back to the 1770s and its most important inhabitant was Cesar Picton, who lived there until 1807. He was brought to England as a slave from Senegal at the age of six but was well treated and left large legacies, which enabled him to become a prosperous coal merchant.

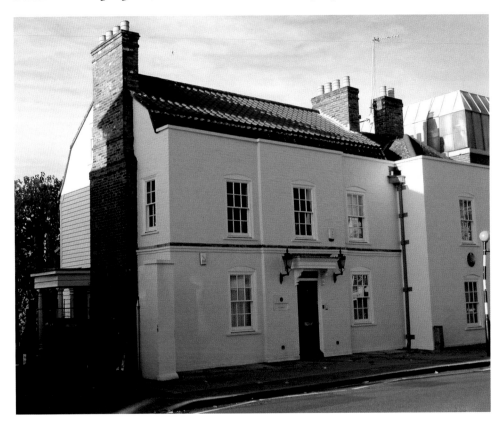

CESAR PICTON DIED in 1836 and there is a small plaque to him marked 'C.P. 1836' in All Saints' church. Apparently he was a very large man. After he died, part of his staircase had to be removed to get him out of the house and his body had to be carefully lowered into the ground using a sledge and rollers. Picton House (No. 52 High Street) soon changed from a house to a shop. In the 1870s and 1880s it was a solicitor's office, and then a boat-builder's office from the 1890s to the Second World War. Montoya Antiques, shown in the old photograph, lasted from 1950 to 1960, and this was followed by 'Glyn's', a short-lived restaurant. Today Picton House belongs to 'George P. Johnson Experience Marketing' and there is a plaque to Cesar on the outside.

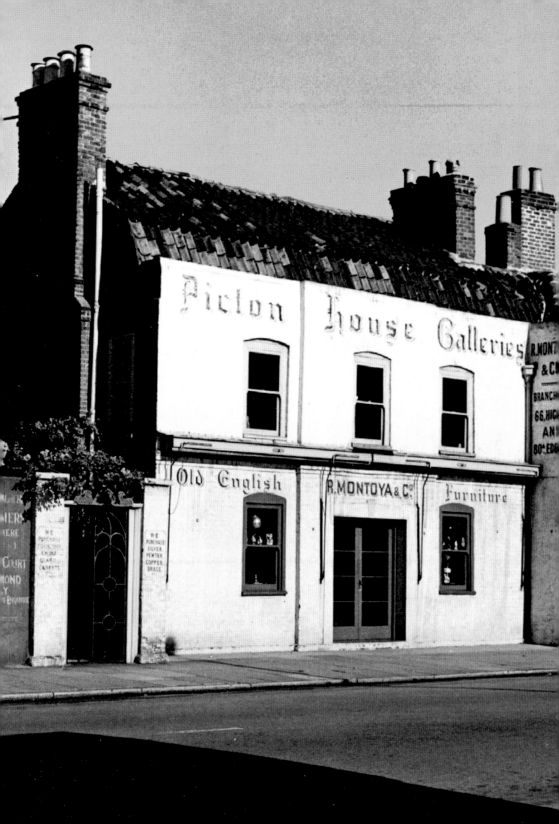

ST JAMES'S ROAD

THE *SURREY ADVERTISER*
Offices, 1941. Both Surbiton and
Maldens and Coombe boroughs
thoroughly photographed all the
bomb damage in their areas but
Kingston did not, so bomb damage
pictures of Kingston are very
scarce. This shows the offices of the
Surrey Advertiser, which were hit in
1941. Naturally there was a press
photographer on hand.

THE *SURREY ADVERTISER* was
rebuilt, and remained at No. 11,
St James's Road until 1967, when
it relocated to Guildford. This whole

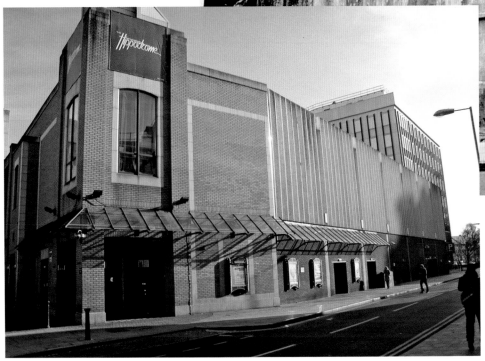

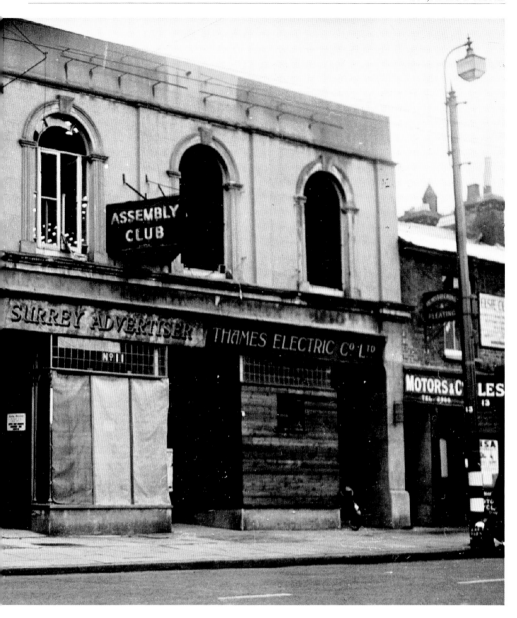

stretch of road was redeveloped and now contains The Hippodrome Nightclub, listed as being at No. 1
St James's Road, which has a car park at roof level. This is pretty much opposite Guildhall 1. Kingston
has a large student population – it is home to both Kingston College and Kingston University – and
this population helps to support several nightclubs. Some people think perhaps there are too many.
The *Surrey Advertiser* was established in 1864 to cover the whole county, but now concentrates
on Guildford, Woking, Elmbridge, Leatherhead and Dorking, leaving the *Surrey Comet*, which was
established in 1854, to cover the Royal Borough of Kingston.

THE CRANE

THE OLD POST House, 1954. Although not clear on this photograph, this building proudly displayed the date AD 1346 and the words 'Ye Olde Poste House'. Neither of these claims was true, which shows how easily history can be fabricated. It was in fact the Crane public house, dating to the early sixteenth century. Here it is a curiosity shop and restaurant. It was knocked down in 1954 because it was deemed to be unsafe.

THE CRANE DATES to before 1516 and its main claim to fame is as the headquarters of the Parliamentary General, Fairfax, in 1647, during the English Civil War. In the late seventeenth century it seems to have become somewhat disreputable and in about 1750 it was renamed the Bear.

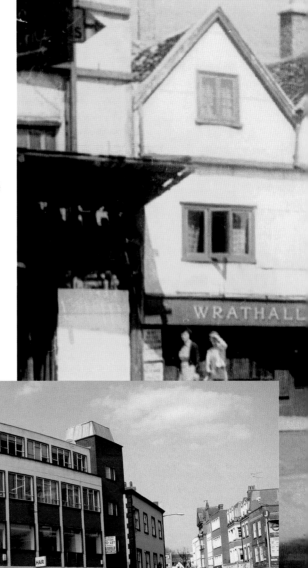

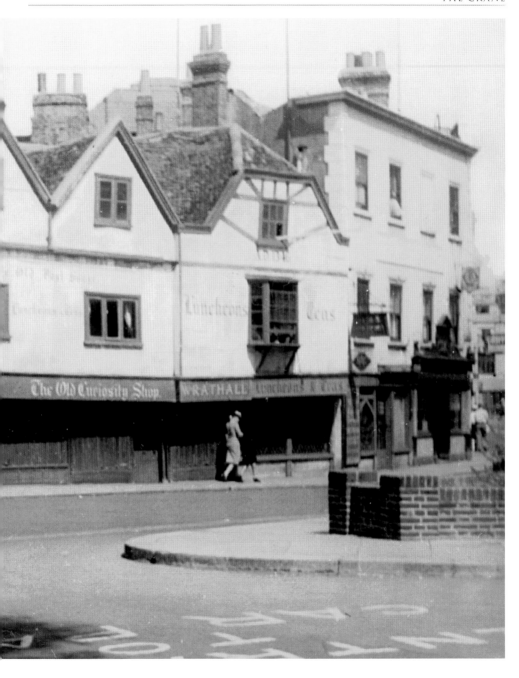

It became the Jolly Butchers in the late eighteenth century but continued to decline until its licence was finally withdrawn just before the First World War. It then became the café and antique shop shown in the earlier photograph. Redeveloped into shops and offices, the new block houses a hairdresser's and a betting shop. The low brick wall to the right in both pictures is part of the Guildhall front garden.

THAMES STREET

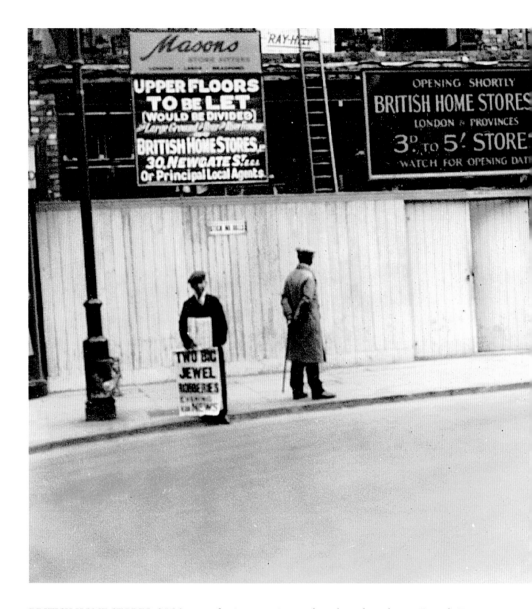

BRITISH HOME STORES, 1931, seen during erection rather than demolition. British Home Stores copied Woolworths' idea and opened their first store in Brixton in 1928. This store opened at Nos 1, 3 and 5 Thames Street in 1933. In 1978, No. 1 Thames Street was sold to become a Bradford & Bingley Building Society branch and the rest of the site was sold the following year when BHS, as they are now called, moved into the new Eden Walk Shopping Centre.

THE ORIGINAL BUILDING can be seen in this picture. The building façade at Nos 3-5 Thames Street was remodelled in 1902 by Nuthalls, a tea import and export and catering business since the 1830s. The ground floor originally had beautiful columns on its frontage as well as

a surfeit of marble and gilt decorations inside, which were presumably removed by British Home Stores. Today, the Bradford & Bingley is now Santander, while Millets, the camping and outdoor suppliers, occupies the main site. Nuthalls opened a famous café here at the back in 1902, which overlooked the river, where the gazebos were also built, and there is still an excellent café at the rear of Millets today.

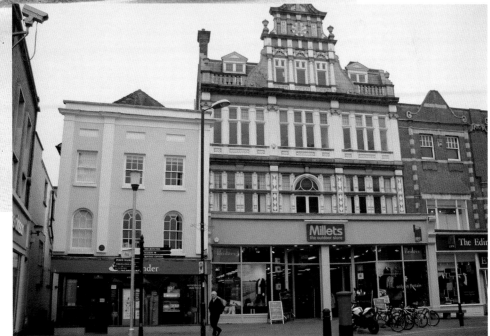

THE ROYAL
COUNTY THEATRE

EDWARD THE ELDER Millenary Pageant, 1902. Laid on to coincide with Edward VII's coronation, this pageant was the most splendid yet seen in the town. This is one of the floats designed by Mr Davey, manager of the Royal County Theatre, which is in the background. Father

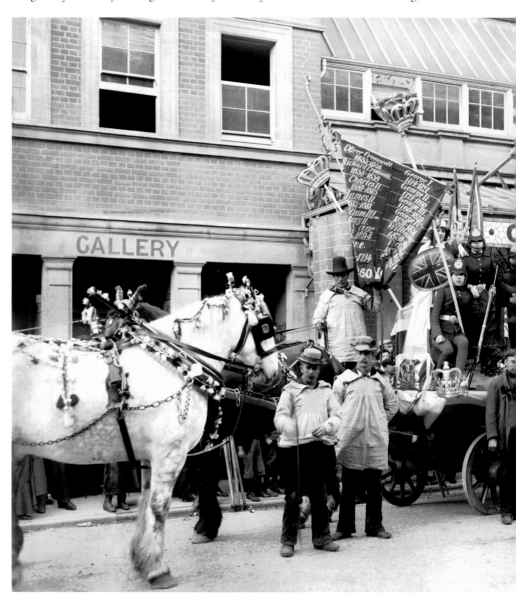

Time sits on top of an hour glass with Britannia at the front of the cart supported by eight young women in military uniforms. The horses are Kingston Corporation horses lent for the occasion and specially prepared by the Corporation grooms.

THE ROYAL COUNTY Theatre had opened in 1897 and Charlie Chaplin made one of his first professional appearances here as a boy in 1903. The theatre became famous for its lavish pantomimes which were written specially for it and later let out to other theatres. Noel Coward's first visit to a theatre was to a Royal County Theatre pantomime when he was four, in 1904/1905. The theatre closed in 1912 and then alternated between being a cinema and a theatre again during the First World War, but decided afterwards that being a cinema was the way to go. This 'Super Cinema' sadly burnt down after a refurbishment in 1940. Times Furnishing Company built a store on the site in 1955 and continued until 1989. Today the site is covered by Sports Direct and PC World – modern leisure pursuits replacing the old.

43

OLD LONDON ROAD

KINGSTON POLICE STATION, 1966. As proclaimed on the front, this station was opened in 1864 to house the Kingston branch of the Metropolitan Police. It lasted until 1968 when the new station was opened alongside the Guildhall. When it came to closing the building, it was found that there was no key for the front door since the building had been open continuously for 104 years.

TODAY THE BUILDING contains uniformed officers of a different kind, as this is where Kingston's traffic wardens are based. In front is David Mach's telephone-box sculpture 'Out of Order', which was erected as part of the public art set up in 1989 when the new one-way system was laid out and Clarence Street was pedestrianised. A storm of

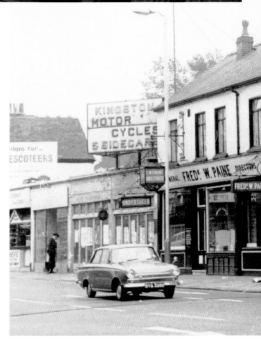

complaints greeted its huge cost – it was several times over budget – but it has now become a useful meeting place as well as a well-loved landmark in the town. I have seen postcards of Kingston's telephone boxes for sale as far away as Dorset! Shop owners in Old London Road have felt a bit cut off from the rest of Kingston by the sculpture (and the main relief road), but things have improved with the addition of a large arch naming the road, subtly inviting shoppers to explore.

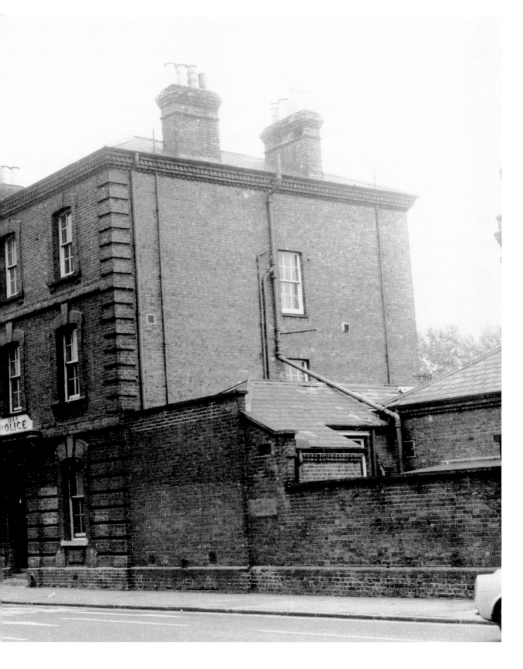

KINGSTON LIBRARY

THE UNVEILING OF the memorial window to the soldiers of the East Surrey Regiment who died in the Boer War (1899-1902). A photograph by Mr Hayes of the Post Office in his guise as Kingston Photographic Society member. He notes that he took this picture at 4.00 p.m. on

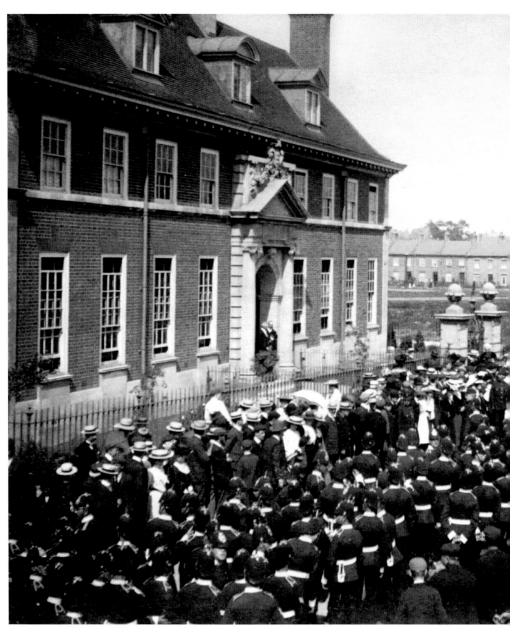

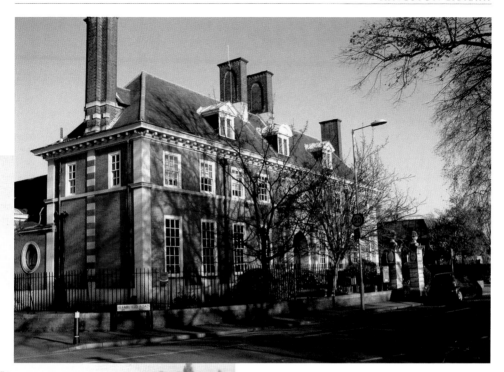

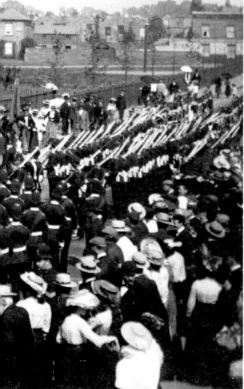

23 June 1905. The parading soldiers are from the local regiment, the East Surreys. Half the local men who died were members of that regiment and enteric fever (typhoid) was the chief cause of death.

KINGSTON'S LIBRARY OPENED in 1903 thanks to a generous donation from Andrew Carnegie, the millionaire philanthropist who was responsible for the erection of hundreds of public libraries. When the Boer War ended, it was decided that the library was the best place for the window and for a roll of honour, where it would be seen by people of all religious denominations; the original plan had been to place them in All Saints' church. The roll lists thirty-four dead from Kingston, but probably fifty or sixty men died from the borough as a whole. The library has never really been large enough to serve a population the size of Kingston and plans are once again afoot to build a larger, more central library.

KINGSTON MUSEUM'S ART GALLERY

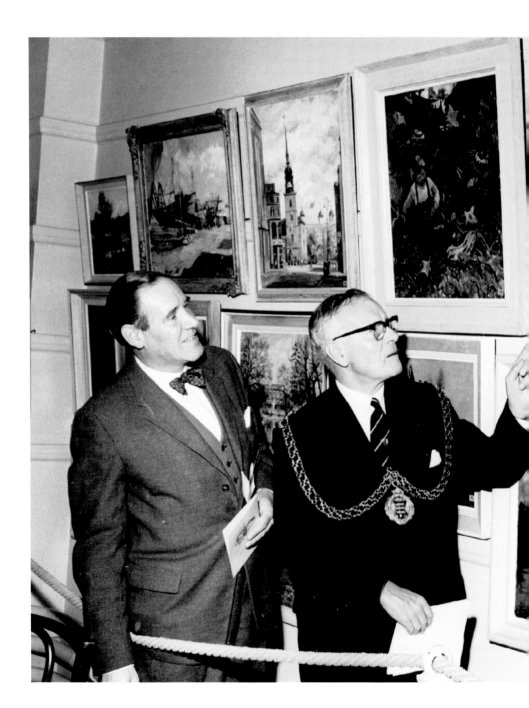

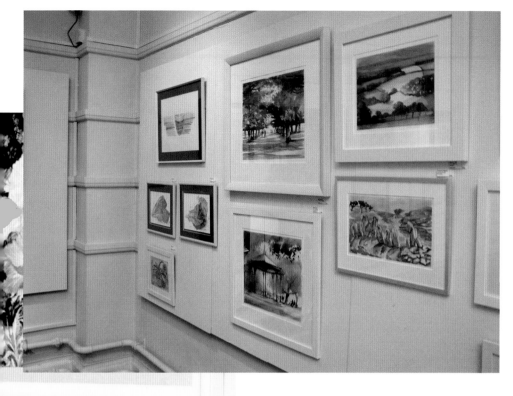

THAMES VALLEY ARTS Club Exhibition, October 1962. The Mayor, Cllr F. Hooker, opened the exhibition in Kingston Museum's art gallery. Thames Valley Arts Club began in 1906 and had their first exhibition in Kingston Museum in September of that year.

THE CLUB HAS held exhibitions in the art gallery nearly every year since. The main exception was the period 1984 to 1992, when the art gallery was used as a local history library. Restored to its former glory, it is shown here in 2011 featuring the Thames Valley Arts Club's latest show. The art gallery is on the first floor of Kingston Museum, which was also built thanks to the generosity of Mr Carnegie. When he came to open the library, he enjoyed his reception so much that he immediately paid for its whole cost (over £8,000, rather than the original gift of £2,000). The borough had already borrowed £6,000, so they were now able to spend this on building the museum.

SNAPPERS' CASTLE

THE OLD PHOTOGRAPH shows Snappers'
Castle in 1956. This was Nos 155-7 London
Road, a pair of semi-detached cottages
incorporating part of a seventeenth-century
mansion which had formed Kingston's first
workhouse. The gothic frontage was added
in 1840 by sculptor Charles Westmacott and
the building was later named Snapper's Castle
after Michael Snapper, who ran an antiques
business there from the 1950s.

IN THE EARLY 1970s the building was
bought by London Transport and, after a
long and unsuccessful fight to preserve it by
the Kingston Society and the Kingston upon
Thames Archaeological Society (KUTAS),

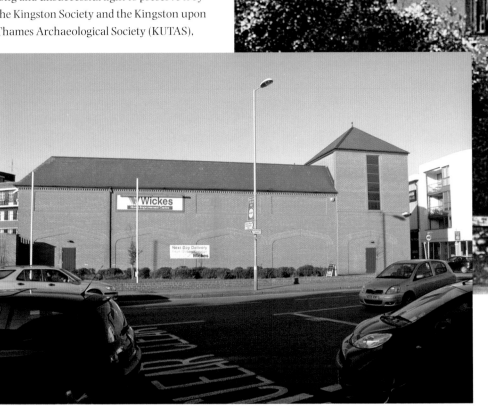

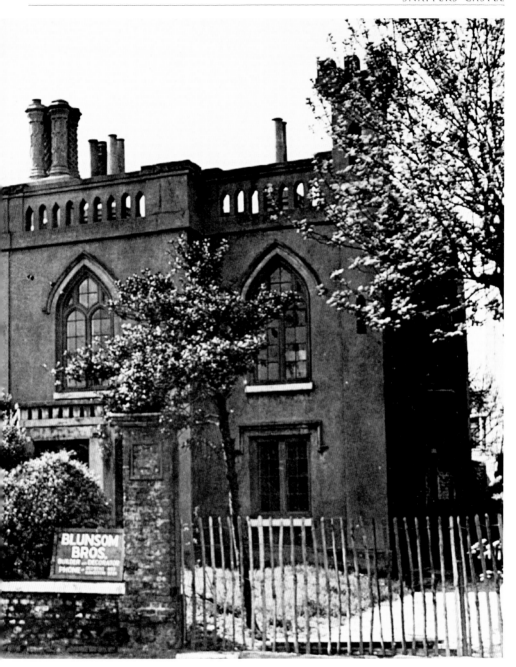

it was demolished in 1978. A new, 'essential'– and also extremely ugly – bus garage was erected in 1984, only to be demolished in 1990 when the privatisation of London Transport apparently rendered it obsolete. The new private firms couldn't afford to run it or didn't need it. There are no covered bus stations in Kingston today: buses merely congregate at the Cattle Market or in Cromwell Road. Today the site of this wonderful old building is a Wickes.

VICTORIA HOSPITAL

VICTORIA HOSPITAL, COOMBE Lane, 1912. This hospital was erected in honour of Queen Victoria's Diamond Jubilee in 1897, and was opened by the Duke of Cambridge the following year. It became part of Kingston Hospital in 1948 (the gynaecological unit), and in 1976 the Royal Eye Hospital was transferred there from Surbiton. A new eye unit was built at Kingston Hospital and these buildings were closed and demolished in 1994. This picture is taken from the garden looking north east.

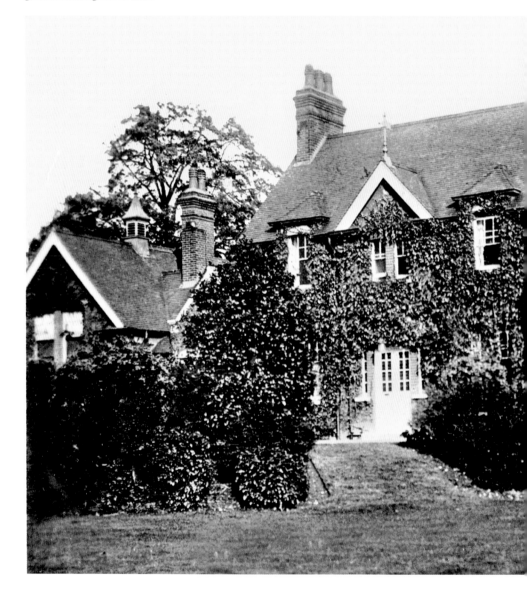

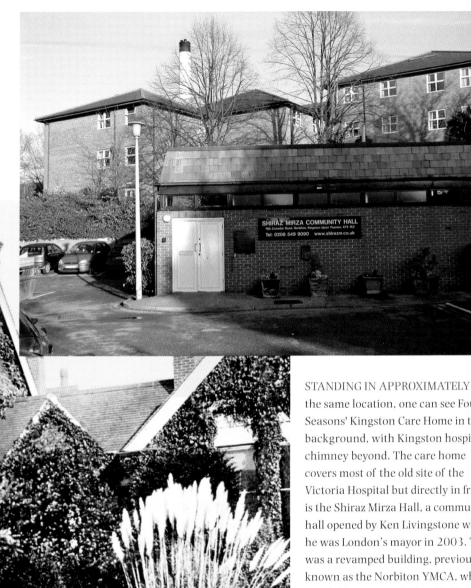

SHIRAZ MIRZA COMMUNITY HALL
76A Coombe Road, Norbiton, Kingston Upon Thames, KT2 7AZ
Tel: 0208 549 9090 www.shirazm.co.uk

STANDING IN APPROXIMATELY the same location, one can see Four Seasons' Kingston Care Home in the background, with Kingston hospital chimney beyond. The care home covers most of the old site of the Victoria Hospital but directly in front is the Shiraz Mirza Hall, a community hall opened by Ken Livingstone when he was London's mayor in 2003. This was a revamped building, previously known as the Norbiton YMCA, where my children enjoyed 'Tumble Tots' in the late 1980s. It is approached via the (apparently unnamed) road to the left of Norbiton Station. Shiraz Mirza was Kingston's mayor in 2000 and 2007 and has opened two community halls, this one in Norbiton and one in New Malden, opened by London mayor Boris Johnson in 2009.

THE THREE TUNS/
NO. 88

THE THREE TUNS, London Road, 1968. Although this is obviously a rebuild of the late
Victorian or Edwardian period, the Three Tuns has been on this site since before 1794 – and

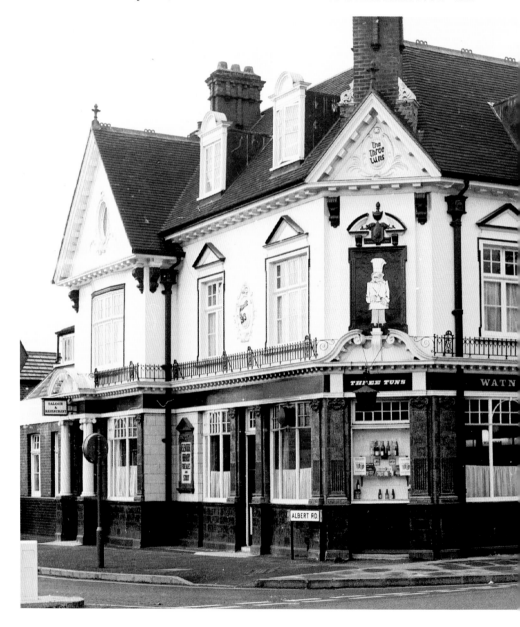

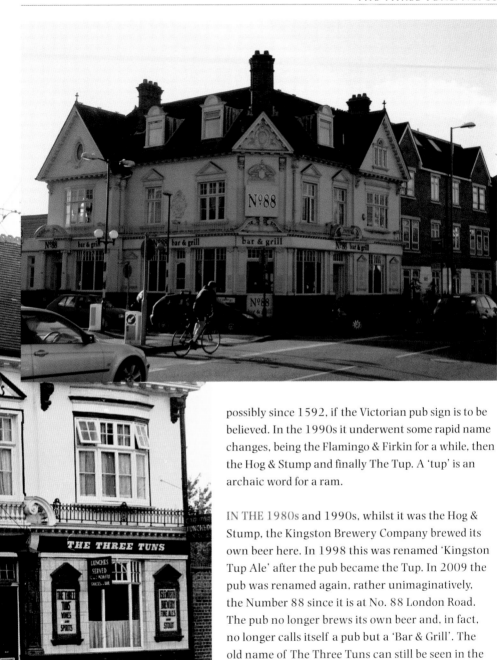

possibly since 1592, if the Victorian pub sign is to be believed. In the 1990s it underwent some rapid name changes, being the Flamingo & Firkin for a while, then the Hog & Stump and finally The Tup. A 'tup' is an archaic word for a ram.

IN THE 1980s and 1990s, whilst it was the Hog & Stump, the Kingston Brewery Company brewed its own beer here. In 1998 this was renamed 'Kingston Tup Ale' after the pub became the Tup. In 2009 the pub was renamed again, rather unimaginatively, the Number 88 since it is at No. 88 London Road. The pub no longer brews its own beer and, in fact, no longer calls itself a pub but a 'Bar & Grill'. The old name of The Three Tuns can still be seen in the tilework on the side of the building though it has been painted over. Pub names often incorporate the number three as it is considered a lucky number and refers to the Holy Trinity. A tun is a large barrel for wine or beer, originally specifically one with a capacity of 252 gallons.

THE BLACK HORSE/
KINGSTON GATE

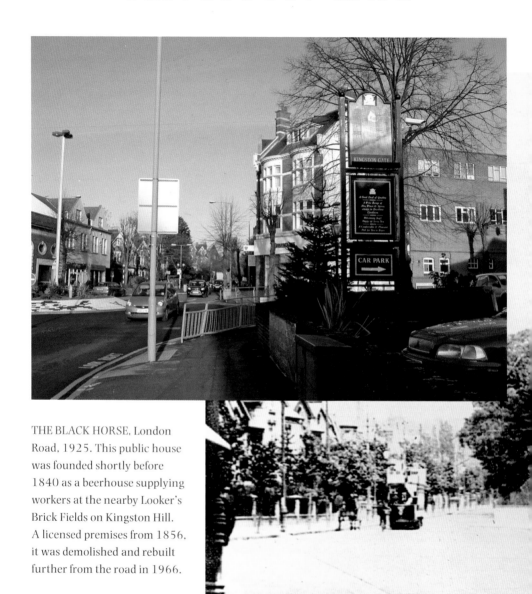

THE BLACK HORSE, London Road, 1925. This public house was founded shortly before 1840 as a beerhouse supplying workers at the nearby Looker's Brick Fields on Kingston Hill. A licensed premises from 1856, it was demolished and rebuilt further from the road in 1966.

ORIGINALLY A HODGSON'S pub (a local Kingston Brewery), the pub is now a Barras pub and was renamed Kingston Gate in 1999, despite being on

the corner of Manorgate Road and rather far from the Kingston Gate of Richmond Park, which features on the pub sign. Initially there was an idea to call it the Eadweard Muybridge after Kingston's famous pioneer photographer, but it was thought people might struggle with the pronunciation, as indeed they do! (It is pronounced Edward Mybridge.) The new roundabout to the left of the picture had the rather skeletal fishes added in 2011 in preparation for the Olympic cycle road race which will go past here. It is now called Three Fishes Roundabout.

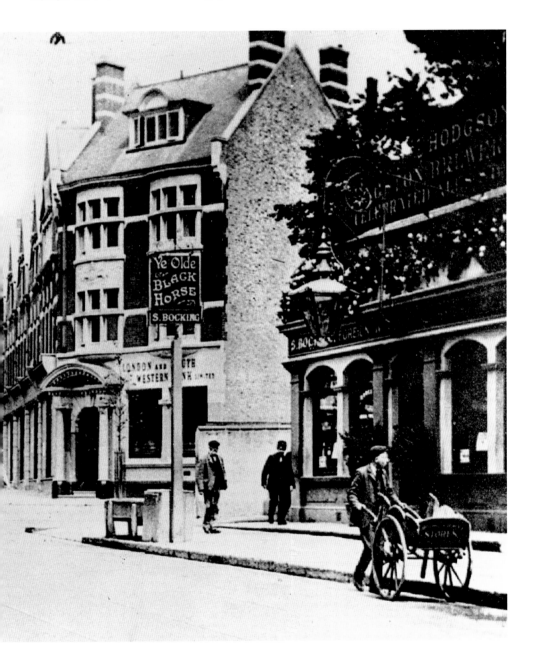

LONDON ROAD

LONDON ROAD IN 1922. This view is looking north from the Liverpool Arms and shows road widening on 24 June 1922. London Road had been widened with the advent of trams, but increased motor traffic was taking its toll. The sign on the works opposite says 'No Hands Wanted', put there by an employer obviously inundated with requests by returned unemployed soldiers, although Kingston was not as badly off for jobs as many towns.

THE LIVERPOOL ARMS was named after the 2nd Earl of Liverpool, who died in 1828. He was, for a while, a local resident and had

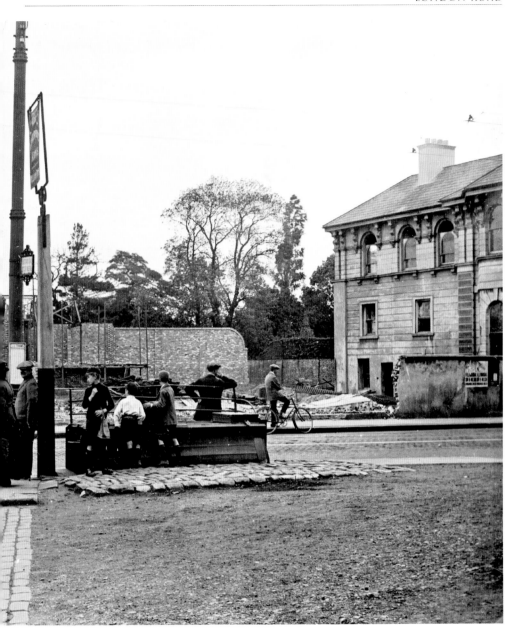

served as prime minister for fifteen years. The pub was renamed the Lady Jane in 1996 and then L.J.'s in 1997. Demolished in 1999, it is now the site of a Blockbuster video store and a Carphone Warehouse. Across the road now are two office blocks. The one on the right is Clarendon House. This was originally Rawlplug House, the head office of the firm who made rawlplugs, those little plastic gizmos which hold screws in walls. Rawlplug moved to Glasgow – where it still is, in a different Rawlplug House – and this building was renamed Clarendon. It has now been converted into flats.

CLEAVES ALMSHOUSES

CLEAVES ALMSHOUSES IN the 1950s. Another picture for a borough guide of the time, this shows Cleaves Almshouses in the London Road. These were provided for by the will of William Cleave in 1667 to house six poor men and six poor women of the town and were built in

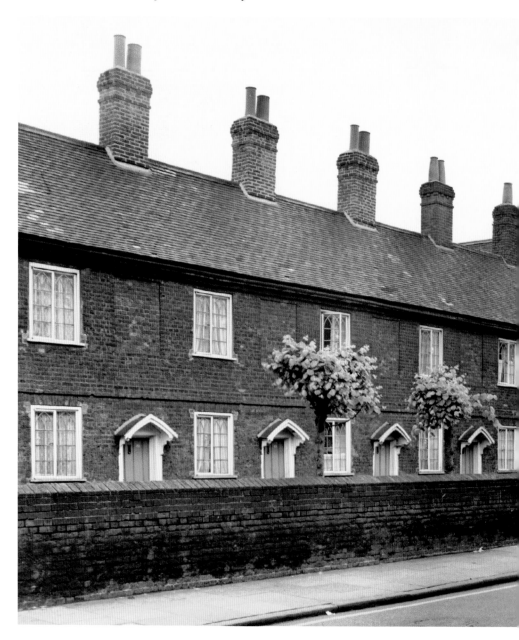

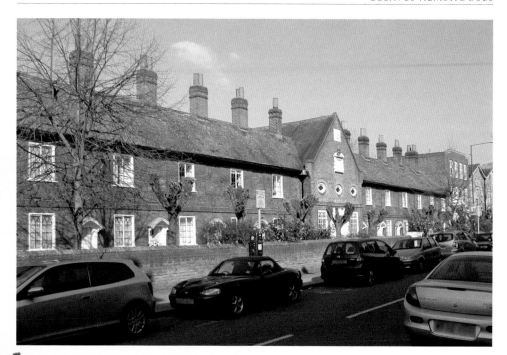

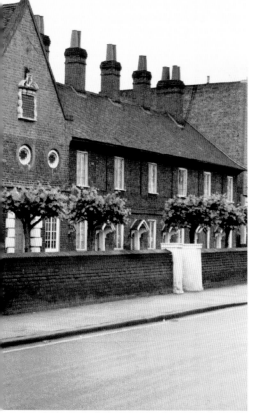

1668-70. Some additional houses for married couples were added in the Victorian period at the side and rear of this original block around a beautiful courtyard garden.

THE HOUSES COUNT as council houses today and are run by the Royal Borough of Kingston. Adverts are occasionally placed in the local press for people to apply to live there, with priority given to former borough employees. Residents are no longer required to pray together, eat together and abstain from alcohol, which were some of the original rules. A history of Cleaves Almshouses was written in the 1970s by one of its residents, Edward (Ernie) Pountney, who was a founder and lifelong member of the Communist Party of Great Britain. He wrote a short history of Socialism (*For the Socialist Cause*) and stood as a Communist candidate in Canbury ward in 1956, polling 113 votes. Shortly afterwards, the Soviet Union invaded Hungary, which dampened his enthusiasm somewhat.

THE EMPIRE

THE EMPIRE THEATRE, Richmond Road, can be seen in the old photograph in 1955. This theatre opened on 24 October 1910 in the presence of Deputy Mayor Alderman Finny. This was the year that also saw theatres open in Richmond and Wimbledon. Unlike these, the Empire concentrated on 'variety' shows but lost its audience with the advent of television and closed on 27 March 1955.

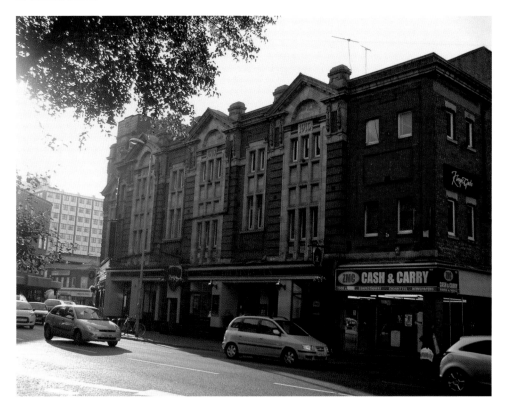

AFTERWARDS, THE BUILDING became a Premier Supermarket until 1968, then a MacFisheries fish market until around 1978, and then the Reject Shop, which sold seconds of various household items. It is unclear when the illuminated dome was removed from the roof. The King's Tun pub was opened by Wetherspoons in the building in 1997. In 2011 the narrow road down the left-hand side was named Nipper Alley in honour of the HMV mascot Nipper, who is buried in Kingston in the area behind Lloyds Bank in Clarence Street. In 2010 the Kings Gate church occupied the upper floor, and they have repainted the 'Empire' sign in red on the side of the building, which is rather fetching and a nice reminder of what the building was.

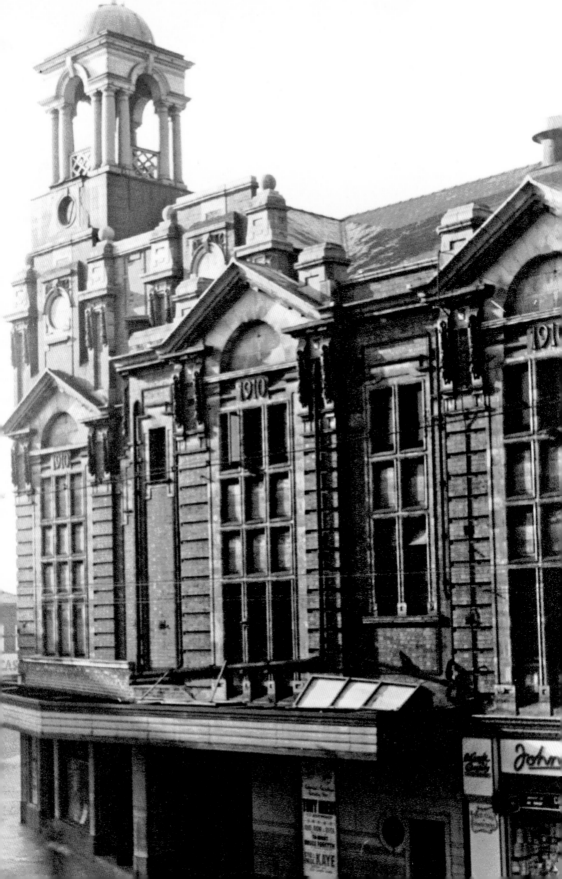

RICHMOND ROAD

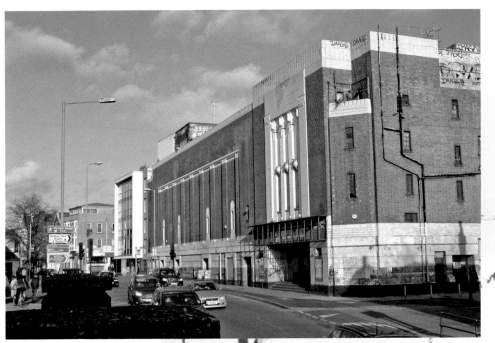

THE CINEM PALACE,
Richmond Road, 1910. This
cinema opened at the end of
1909 but was not converted
to show 'talkies' and closed
in 1931. It was replaced on
the same site by the Regal, a
2,500-seat cinema, which
lasted until 1961. The
Wurlitzer from the Regal
is in Brentford Musical
Museum. Other things to
notice on this photograph
are the 10mph speed limit
for trams and the two figures
in the middle of the picture
that have been scratched off
the negative, I suppose to
give a better view.

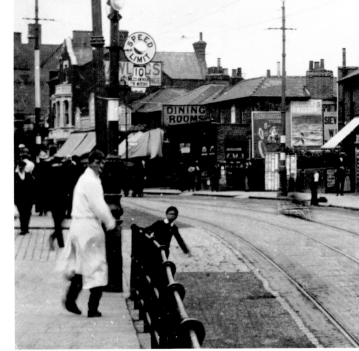

THE TRAMS LEFT Kingston in 1931 and the succeeding trolley buses in 1961. Also in 1961, the Regal became the ABC, but it closed in 1976 as cinema audiences fell and became the Gala Bingo Hall. Bingo's popularity was huge in the 1970s but it has declined rapidly in recent years and the Gala Bingo Hall closed in 2010. The current owner, who owns the Essence nightclub in Kingston, is trying to get permission to turn the building into another nightclub, but initial permission for this has been turned down by the borough planners. A local church group has also expressed interest in the building, which is rapidly deteriorating as no one looks after it.

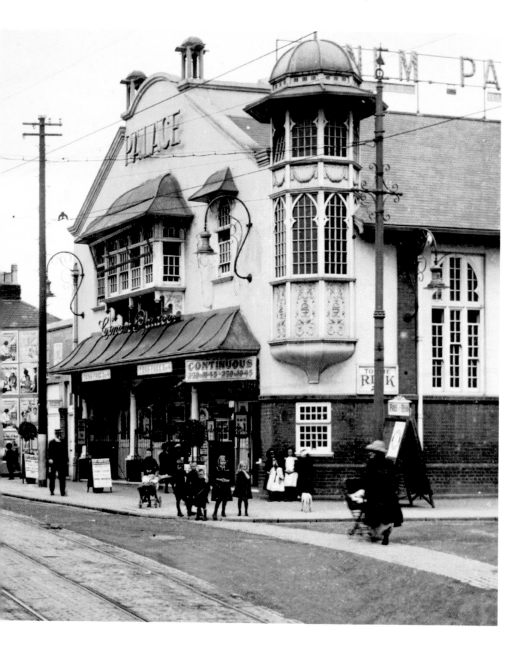

STEVEN'S EYOT

LAUNCH OF A lifeboat at Kingston, 1908. Why a Worthing lifeboat should be launched into the Thames at Kingston is a bit of a mystery until you realise that Kingston has a long tradition of building boats as well as using them. Turks Boat Builders go back to 1777 and Burgoine's was another famous name at the time this boat was launched. Lifeboat launches were big events with races and side shows.

THE ISLAND IN the Thames here was known as Tathim's Island in around 1900 but by the First World War it had become Steven's

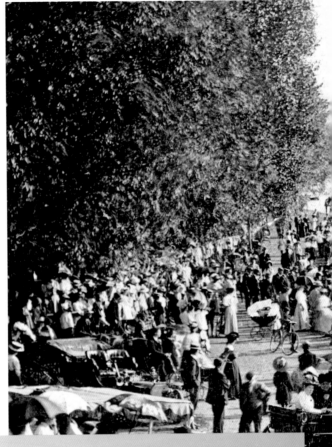

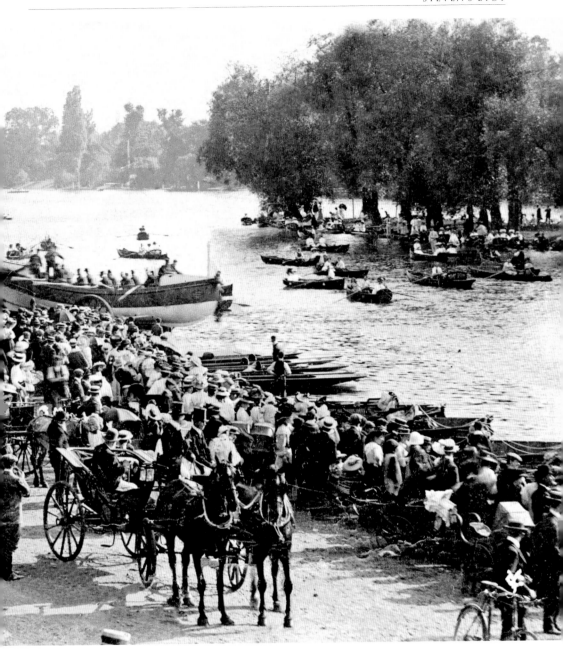

Eyot. Later, in the 1930s, it was called Steven's Eyots (plural) because part had broken away, forming two islands. The banks are now reinforced and these gravel islands no longer move about! Just to the north is another small eyot called Tea Island from Edwardian times when people would hire a punt, 'mess about' on the river and have a picnic lunch on one of the islands. This view is taken from the Albany Boathouse. Today Steven's Eyot has its own boathouse and is difficult to see because of the numbers of boats moored alongside it.

TIFFIN GIRLS' SCHOOL

TIFFIN GIRLS' SCHOOL, 1941. These large trenches were built in front of the school and were rediscovered in 1999 when the new Fern Hill Primary car park was being laid out. Tiffin Girls' moved to a new building next door in 1987 (the old Tudor School) and this building is now the North Kingston Centre, home of adult education and Kingston Local History Room and Archives among others.

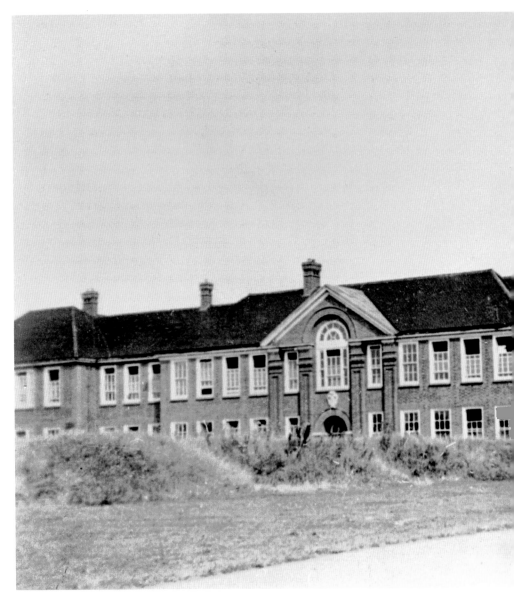

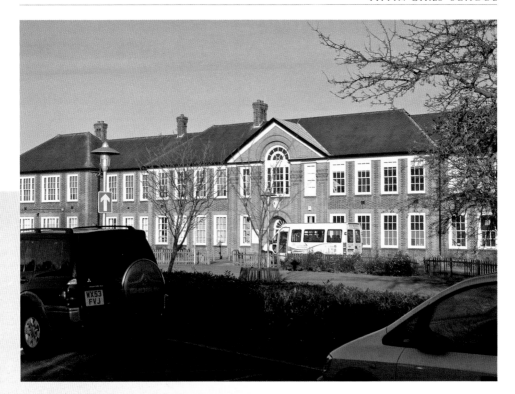

THE NUMBER OF children continues to rise, and a new school is now needed in north Kingston. Grey Court School in Ham has room for expansion but that comes under the borough of Richmond, and Kingston would rather build its own new school. The North Kingston Centre has been designated as the best site and all the current occupants are scheduled to leave in 2013. It is hoped that the Local History Room can be relocated on the same site as the museum. Apart from adult education, new homes will also have to be found for the Mecklenburg Unit, which teaches excluded children, and Kingston and Richmond Community Transport. At the time of writing there are still no funds available from central government to build the school.

CAMBRIDGE ROAD

TICKNER'S BUTCHERS, No. 36 Cambridge Road, *c*.1900. Just after this photograph was taken, Tickner's moved to No. 54 Richmond Road, where his business flourished until the First World War. Mr F. Watkins took over the Cambridge Road shop for a couple of years and was then replaced by Henry Holmes – being a butcher does not appear to have been a very secure trade at the time. This marvellous display represents a day's trade, as in the days before refrigerators all this meat would have been distinctly iffy by the end of the day, especially if it was sunny.

No. 36 CAMBRIDGE ROAD was renumbered No. 76 in 1926. Most of this side of the road was demolished in the 1960s in preparation for the building of the Cambridge Road Estate, but No. 76 and the Duke of Cambridge pub (just to the left of the picture) survived for longer. The Duke of Cambridge was here from at least 1856 and is named after the local landowner at that time. It was demolished in 2004. An empty office block now occupies the site to the right of the Duke of Cambridge, but the author is uncertain whether this is on the exact site of the old butcher's shop or whether that lay just to the right in the forecourt of Europcar, which seems more likely. The area really has changed beyond recognition.

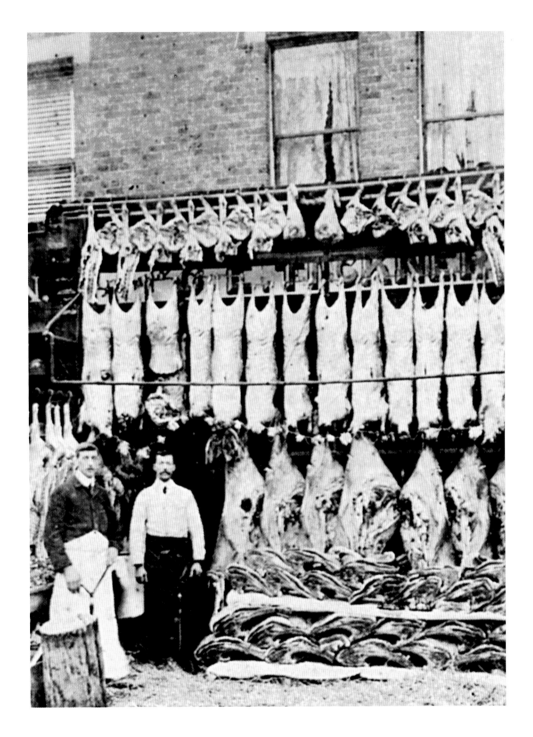

BRIDGE
OVER THE
HOGSMILL

THIS VERY RURAL scene of around 1920 shows
the old wooden bridge over the Hogsmill in Oil
Mill Lane. This rickety structure drew children
from all over to paddle in the dubious waters.
It was replaced in 1924 by the Athelstan road
bridge, which served well for over seventy years
but became so weak that traffic was reduced to
single file from 1997 to 2001, when the bridge
was reinforced.

OIL MILL LANE was renamed Villiers Road in
1920 after Francis Lord Villiers, who was killed
nearby in an English Civil War skirmish in 1648:

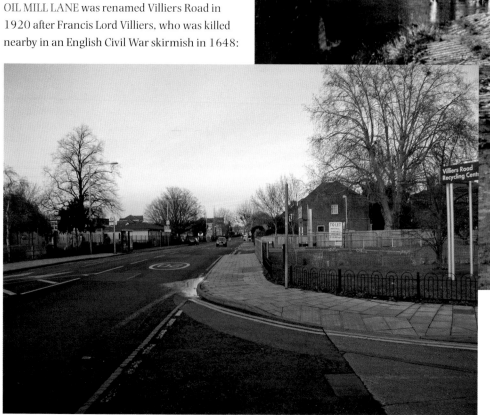

the Battle of Surbiton, the last real battle of the second civil war. Today the river is hard to see after the widening and strengthening of the bridge, but the red bricks on the right of the photograph are lining the far bank of the Hogsmill. The road to the right leads to the Villiers Road Recycling Centre (colloquially known as 'the dump'!). On the left of the picture is Athelstan Primary School, named after the most famous of Kingston's Saxon kings and the man generally regarded as the first king of England.

THE ANGLERS

THE ANGLERS, No. 61 High Street, 1910. There used to be a beerhouse on this site called the Queen's Head, which dated from at least 1692 and welcomed travellers coming up the Portsmouth Road. Sometime between 1813 and 1828 it changed its name to The Anglers and became licensed to sell spirits as well. An Isleworth brewery bought the lease in 1847.

THOUGH THE BUILDING had large sums spent on it, it was pulled down and rebuilt further back from the road in 1901. This is the building shown in the old photograph with a dome made

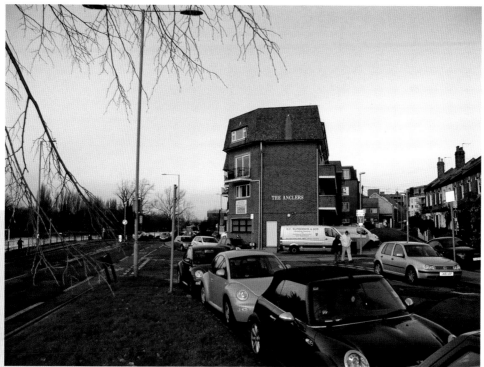

of copper. It became an inn as well, with seven bedrooms. The Anglers closed in 1958 and was replaced by this block of flats, which give splendid views over the Thames and retain the Anglers' name. Not so many people fish in Kingston nowadays – in fact, they have been actively discouraged at the John Lewis site where I fished once or twice as a boy. Fish, especially salmon, three of which feature on Kingston's coat of arms, used to be a staple diet for Kingston's inhabitants. Indeed, in 1781, the local apprentices complained at having to eat salmon more than three days a week!

SURBITON WAR MEMORIAL

SURBITON WAR MEMORIAL, 1921. The First World War changed Kingston dramatically. Since there was a barracks in the town, men came from all over Surrey to enlist. Nearly 4,000 of those who enlisted at Kingston never came back. Perhaps half of these were local men, including some from Surbiton and Old and New Malden. Surbiton's war memorial stands outside Surbiton Library and was unveiled in July 1921 by Lieutenant General Sir Edmond Elles.

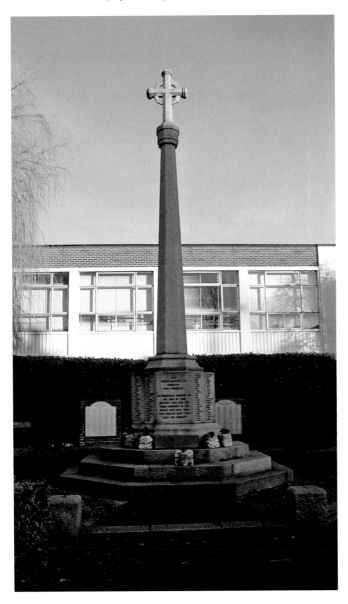

A NOTABLE SURBITON soldier who is not on the memorial because he survived the war is Lance Sergeant Douglas Belcher. A Surbiton man, educated at Tiffin School, he won the Victoria Cross in 1915 whilst serving with the 1/5th The London Regiment. He elected to hold the line against superior numbers when other units had been pulled back and succeeded in keeping the Germans at bay until reinforcements arrived. He was later promoted to captain and died in Claygate in 1953. Today there are further memorial plaques on the back wall listing all those who died in Surbiton in the Second World War, including civilian casualties of the Blitz and the later V1 'doodlebug' attacks. Behind are the library offices and halls built in the 1950s and later extended. Many local societies have their meetings here.

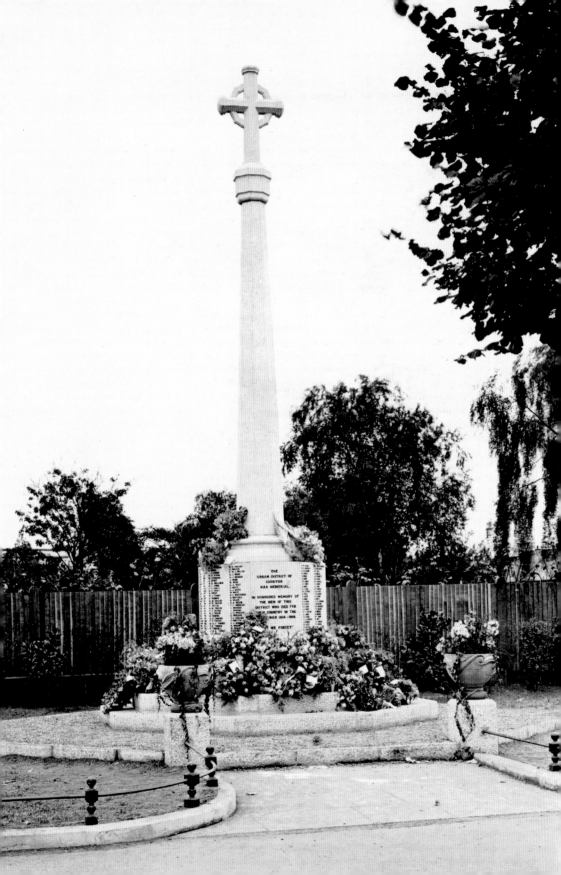

FROM THE ODEON
TO WAITROSE

SURBITON ODEON, SUMMER 1973. Surbiton Odeon was designed by Joseph Hill and was his only Odeon. It opened on 14 April 1934 in Claremont Road and the first film was *Captain Blood*, starring Errol Flynn. The building originally had 'ODEON' in 9ft high letters above the entrance canopy. These probably came down in the Second World War. The Odeon had seating for 1,500 people, 974 in the stalls and 528 in the circle.

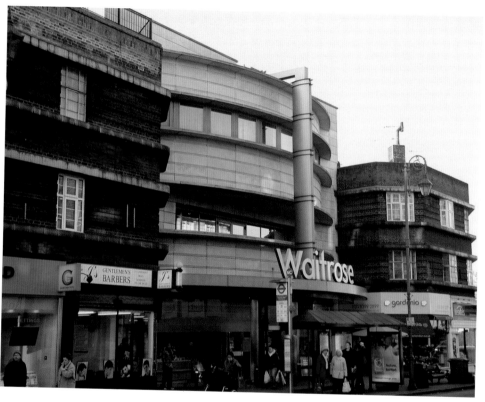

SURBITON ODEON CLOSED in 1975 on 8 February with James Caan in *Cinderella Liberty* and Alan Alda in *To Kill a Clown*. From 1975 to 1977 it was Sapphire Carpet Warehouse. In the early 1980s a B & Q do-it-yourself store took over the site, during which period its condition rapidly deteriorated. B & Q eventually sold up and the building was demolished in 1998, being beyond repair, and was replaced with this Waitrose supermarket. The 1930s shops and flats to either side remain, and it is interesting to note that the bus stop in front is still in the same place. Surbiton no longer has a cinema.

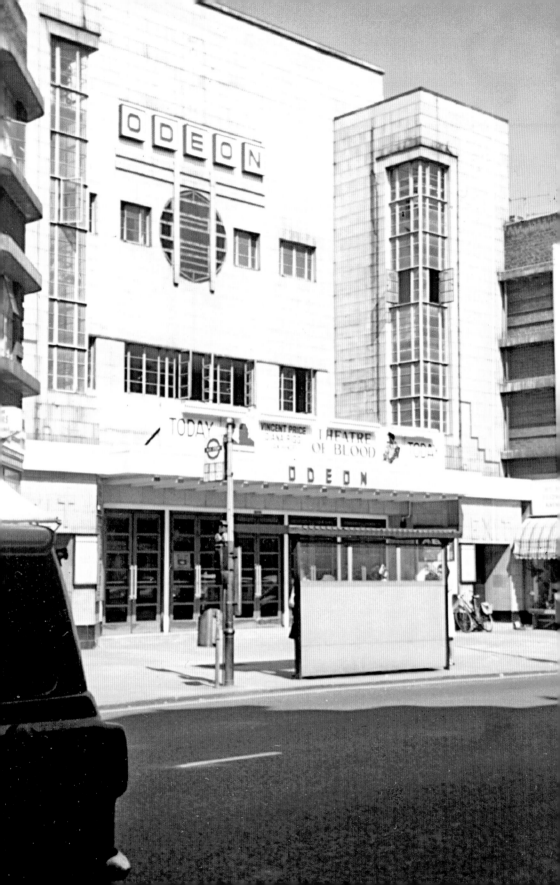

SURBITON LAGOON

SURBITON LAGOON, 1950s. Surbiton Lagoon opened in 1934 in Raeburn Avenue. It was designed by H. T. Mather and cost £18,000. It was 50m x 27m and featured a café, ice-cream bar, and large areas for sunbathing.

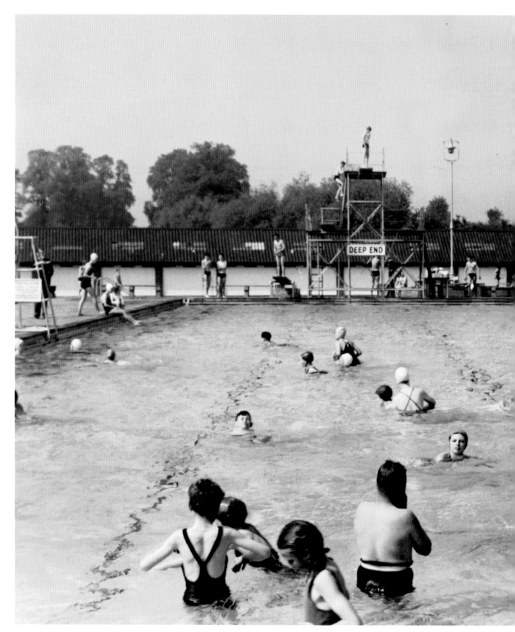

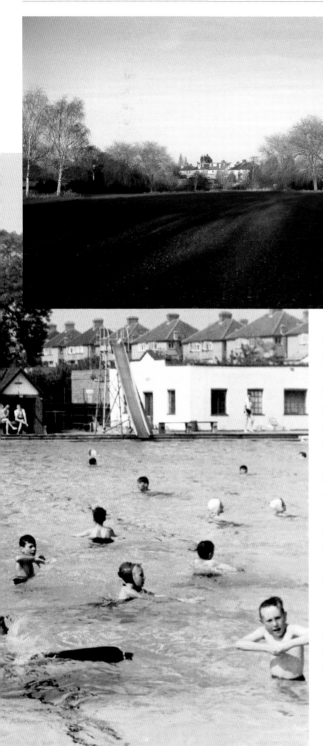

OUTDOOR BATHING IN unheated pools declined in popularity in the 1970s (apart from the drought year of 1976) and the Lagoon closed at the end of the 1979 season, never to reopen (despite quite a large public protest). It seems that it needed quite substantial repairs and had never made much of a profit since it was run as a public service to encourage health and fitness. The ability to swim was also considered vital in a riverside town. Houses were built on part of the site but, where the pool used to be, a small area of parkland was laid out, now frequented by local dog walkers. Surbiton has been without a public swimming pool ever since, unlike Kingston and New Malden.

DUKES AVENUE/
HIGH STREET

CHURCH PARADE, NEW Malden, 1914. In the summer before war broke out, life went on as normal. New Malden Fire Brigade led this procession, as they did most others in the town. Chief Fire Officer was Captain Charles Kirk, who was appointed in 1896 and did not step down

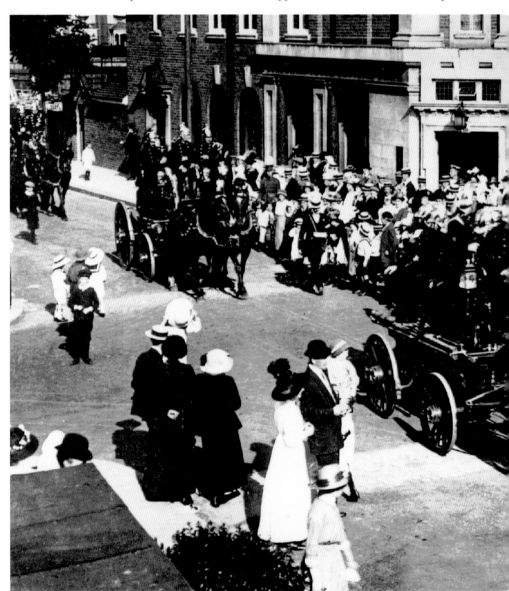

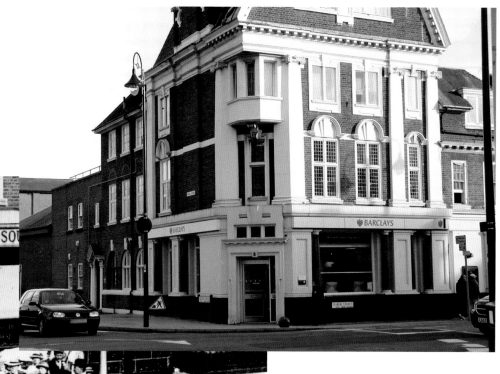

until 1936, seeing the introduction of motorised engines in 1927. The London & South Western Bank can be seen in the background.

THE OLD PHOTOGRAPH is unusual in that the procession is not going down the High Street but will process through the Groves for everyone to see. The fire service left its offices next door to the council buildings in the High Street in the 1980s and moved to Burlington Road, and New Malden Fire Service is now part of a team with Wimbledon and Mitcham. The London and South Western Bank was taken over by Barclays in 1918. Directly behind Barclays is the New Malden Waitrose. The erection of the two skyscrapers at this end of the High Street, the C.I. Tower and Apex Tower, has created a bit of a wind tunnel and means that this junction is now noted for the fierce buffeting winds which occur on most days.

BYPASS
BUSINESSES

VENNER TIME SWITCHES, Shannon
Corner, 1946. This firm was founded
in 1932 alongside the new Kingston
Bypass and made timing mechanisms
for bombs during the Second World War.
This photograph was taken just after the
trenches in front of the building were filled
in. In peacetime Venners made timers for
parking meters and finally closed in 1976.

TODAY THE BYPASS goes through on
a flyover and these roadside businesses
are approached via slip roads – which
are not friendly places for pedestrian
photographers! This stretch of the bypass

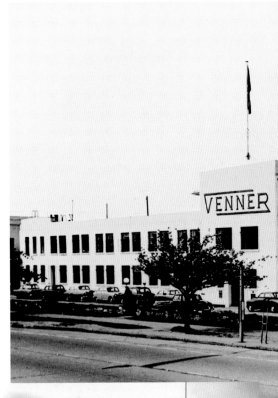

is called Beverley Way after the nearby Beverley Brook, a Thames tributary which separates
the borough of Kingston from that of Merton. The Wyvern Estate was built in place of Venners
and houses half a dozen units. Each unit can contain four or five small businesses or one large
one such as Paul Simon Furnishings and World of Golf. The Big Yellow Storage Company is in
approximately the same location as Venners and takes up all of units 1-3.

SHANNON CORNER

SHANNON CORNER, 1950. Shannon Corner is named after Shannon's Stationary Firm, which used to be just to the left of this picture (where B & Q is today). Postally New Malden, this area is east of the Beverley Brook and so falls within the borough of Merton. The Duke of Cambridge pub opposite was built in 1925 to supply nearby businesses in Burlington Road, and in anticipation of the bypass which now runs through from left to right.

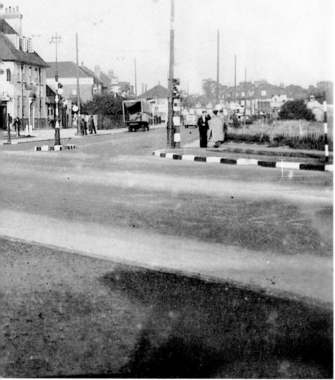

TODAY THE DUKE of Cambridge is hard to see since the A3 passes through on a raised flyover constructed in the 1960s. The Duke of Cambridge, like the Norbiton pub of the same name, was named after the local landowner but now is no longer a pub, having become a Krispy Kreme donut outlet some years ago. The side of B & Q can just be seen on the left of the photo where the slip road leads to the Wyvern Estate. On the third Sunday of the month there is a classic American car meet held at Krispy Kreme where old Mustangs, Chevrolets etc can be seen.

TOLWORTH FOUNTAIN

TOLWORTH FOUNTAIN WAS opened on 29 July 1901 at the junction of Ewell Road and Ditton Road near the Surbiton/Tolworth border. It was provided by Steven Kavanagh, along with two plots of land, in exchange for the publicly owned Old Tolworth Pond which he wanted to build on.

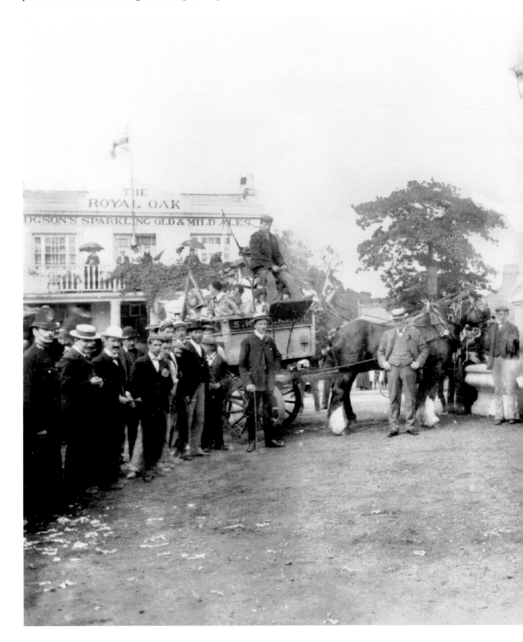

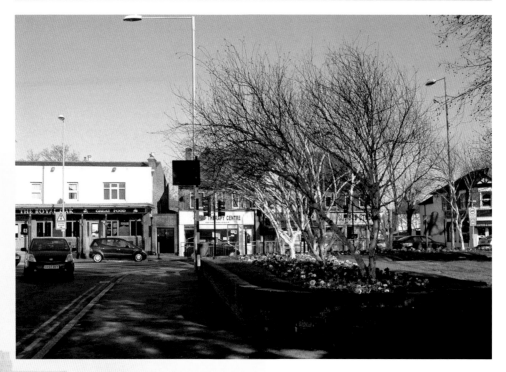

It was opened by the chairman of Surbiton Urban District Council, and free buns were handed out to 500 school children who attended the ceremony.

THE FOUNTAIN WAS removed in 1936, partly because the decrease in horse traffic made it unnecessary, but mostly because it got in the way of the cars and lorries that were now being used instead. Its broken pieces and inscribed plaques were rediscovered in 1973 by workmen laying out a travellers' site between Fullers Lane North and Cranborne Avenue. The pieces had apparently been used as hardcore for a car park. There was a campaign to save the inscription plaques for posterity but, if it was successful, their current whereabouts is unknown. The Royal Oak is still there and the site of the fountain is somewhere between the flower bed and the pedestrian crossing.

THE RED
LION,
TOLWORTH

TRAM AT TOLWORTH, *c.*1920. This
tram is standing at the terminus outside
the Red Lion public house ready to set
off for Richmond Park Gates. It is a Type
W open-topped tram. The route from
Tolworth to Kingston opened at the
beginning of the service in March 1906
and was extended through to Richmond
Park Gates in May. A proposed offshoot to
Hook was never built.

TROLLEYBUSES REPLACED TRAMS in
1931, and in 1933 the overhead wires
were extended a few hundred yards
eastwards to take the trolleybuses to
Warren Drive. The trolleybuses ceased

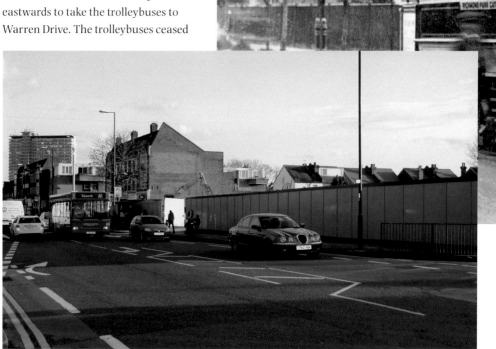

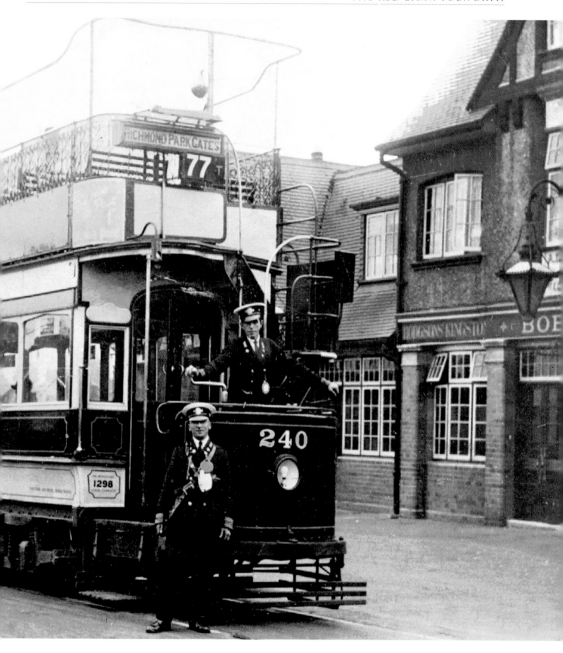

in 1961 and were replaced with motor buses like the 265 in the picture. The Red Lion dated to before 1845. It was renamed Sullivans in 1985 but everyone still called it the Red Lion; it was, after all, on the corner of Red Lion Road. Sadly it was demolished in 2011, and flats are going to be built on the site. On the left in the distance can be seen Tolworth Tower, which sits at the far end of the Broadway. Plans are currently underway to have a pedestrianised 'Greenway' down the middle of Tolworth Broadway.

TOLWORTH TOWER

TOLWORTH ODEON, LIKE most other Odeons, was opened in the 1930s during cinema's heyday. It opened on 9 June 1934 and the first film it showed was Eddie Cantor in *The Kid from Spain*. Also, like most Odeons, it failed to survive the onslaught of television and closed on 10 October 1959

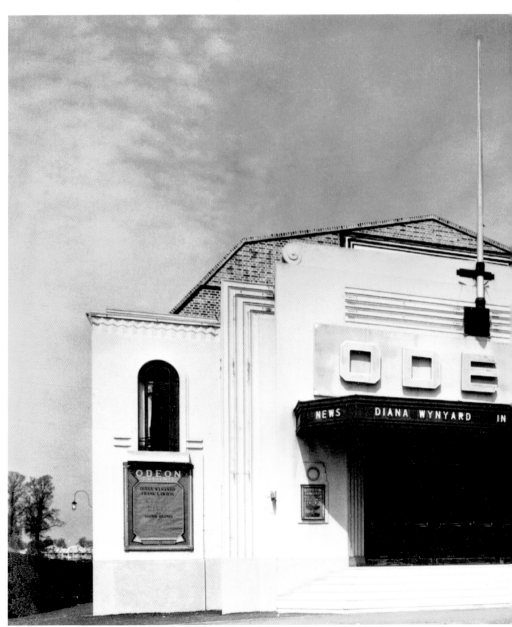

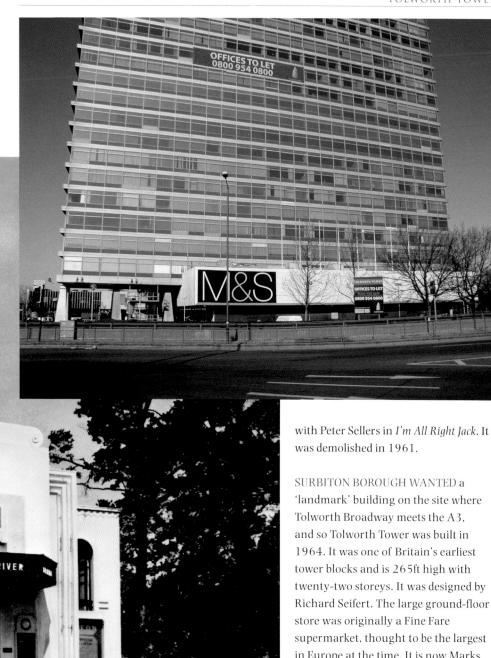

with Peter Sellers in *I'm All Right Jack*. It was demolished in 1961.

SURBITON BOROUGH WANTED a 'landmark' building on the site where Tolworth Broadway meets the A3, and so Tolworth Tower was built in 1964. It was one of Britain's earliest tower blocks and is 265ft high with twenty-two storeys. It was designed by Richard Seifert. The large ground-floor store was originally a Fine Fare supermarket, thought to be the largest in Europe at the time. It is now Marks & Spencer and there is also a Boots on the ground floor. The Ordnance Survey occupied much of the office space for a while but, as the sign says, most of the building is currently empty, although a Travelodge Hotel occupies some floors.

HOOK

THE POST OFFICE, Hook, can be seen in the old photograph, *c.*1937. To the right of the post office is Pointer's Bakery, which became the National Westminster Bank. There was some uproar a few years ago when the post office was renamed Chessington post office despite being in Hook. It seems the Royal Mail was getting confused with their post office at Hook in Hampshire.

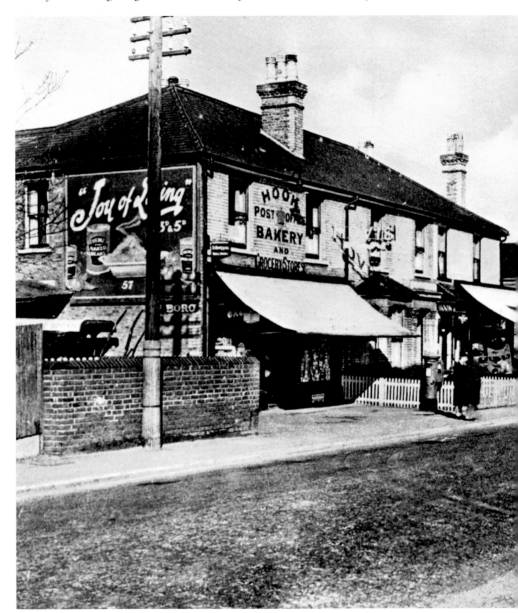

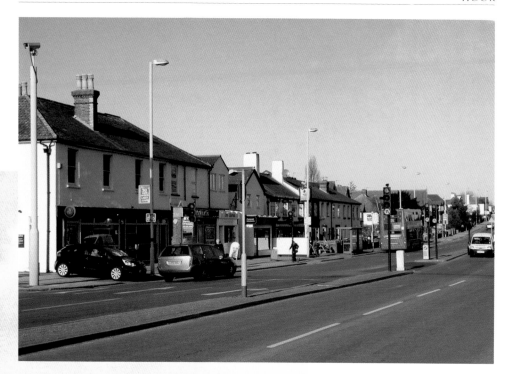

TODAY THE POST office is located in the Tesco Express further south and is known (as is the Tesco) as the Chessington Hook branch, whilst the NatWest bank has expanded to include the old post office site. The tall white chimneys in the middle of both pictures mark The Lucky Rover pub, which dates from shortly before 1884 and is well known for its horse racing on the telly and poker night on Thursdays. To the right, out of picture, is the new Hook Centre, which acts as an excellent community centre for the area, with a library, council help desk, and café. The name Hook simply comes from the place occupying a hook-shaped piece of land at the southern end of Kingston parish and manor.

Other titles published by The History Press

Not a Guide to Kingston upon Thames
SIMON WEBB

Kingston upon Thames is a royal borough and a Surrey market town situated on the banks of the River Thames. A renowned centre for retail and the arts, Kingston boasts green spaces, café culture and architecture. This engaging little book explores both the modern life of this most vibrant and exciting of London boroughs, as well as exploring its historical background.

9780752479682

South London Murders
PETER DE LORIOL

Over the centuries South London has witnessed literally thousands of murders. Those included within the pages of this book have shocked, fascinated and enthralled the public and commentators for generations, from St Alphege's murder in Greenwich in the eleventh century to the murders of Lambeth prostitutes by a crazed hospital doctor at around the same time as Jack the Ripper. Richly illustrated and based on original documents and trial notes, this book will delight anyone with any interest in true-crime history.
9780750944267

Life in Roman London
SIMON WEBB

Seven years after the Roman invasion of Britain in AD 43, Londinium was created. It would rise to become one of the most important Roman cities in northern Europe. Rather than focusing upon a handful of important figures, this book explores the lives and concerns of the ordinary citizens: the shops, houses and streets in which the majority of the 60,000 inhabitants of the city lived. In doing so, it reveals a city very different from the clean, white, classical metropolis familiar from the books of our childhood.

9780752465364

Life in Roman London
JOHN CLOAKE

Richmond and Kew share a long history as an important royal estate, the site of a succession of palaces and parks from the original manor house and the two medieval royal palaces of Shene to the great Tudor palace in the Old Deer Park. This volume takes the story up to 1660.

9780850339765

Visit our website and discover thousands of other History Press books.
www.thehistorypress.co.uk